simple screen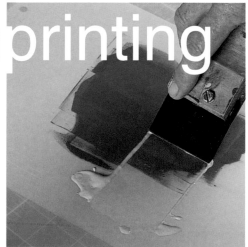printing

simple screenprinting

basic techniques & creative projects

Annie Stromquist

LARK BOOKS

A Division of Sterling Publishing Co., Inc.
New York

dedication

*To my husband, Joe, and to my mother,
Marian Hughes Shuff.*

Editor: Valerie Van Arsdale Shrader

Art Director: Tom Metcalf

Photographer: Keith Wright

Cover Designer: Barbara Zaretsky

Illustrator: Orrin Lundgren

Assistant Editor: Rebecca Guthrie

Associate Art Director: Shannon Yokeley

Editorial Assistance: Delores Gosnell,
Nathalie Mornu

Interns: Meghan McGuire,
Amanda Wheeler

Library of Congress has cataloged the hardcover edition as follows:

Stromquist, Annie.
 Simple screenprinting : basic techniques & creative projects / Annie
Stromquist.
 p. cm.
 Includes bibliographical references and index.
 ISBN 1-57990-490-4
 1. Screen process printing 2. Serigraphy. I. Title. II. Title: Simple screen printing.
TT273.S77 2004
745.7'3--dc22

 2004004991

10 9 8 7 6 5 4 3 2 1

Published by Lark Books, a division of
Sterling Publishing Co., Inc.
387 Park Avenue South, New York, N.Y. 10016

© 2004, Annie Stromquist

Distributed in Canada by Sterling Publishing,
c/o Canadian Manda Group, One Atlantic Ave., Suite 105
Toronto, Ontario, Canada M6K 3E7

Distributed in the U.K. by Guild of Master Craftsman Publications Ltd.
Castle Place, 166 High Street, Lewes, East Sussex, England BN7 1XU
Tel: (+ 44) 1273 477374, Fax: (+ 44) 1273 478606
Email: pubs@thegmcgroup.com, Web: www.gmcpublications.com

Distributed in Australia by Capricorn Link (Australia) Pty Ltd.
P.O. Box 704, Windsor, NSW 2756 Australia

If you have questions or comments about this book, please contact:
Lark Books
67 Broadway
Asheville, NC 28801
(828) 253-0467

Manufactured in China

ISBN 1-57990-490-4 (hardcover) 1-57990-664-8 (paperback)

table of contents

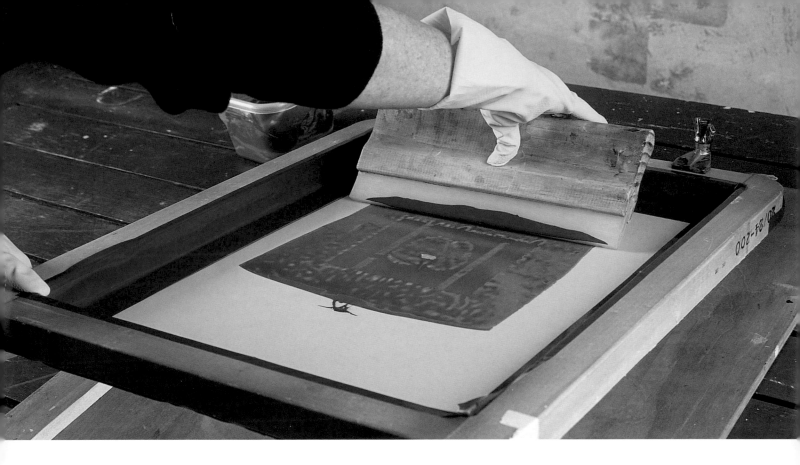

introduction

There is a magical moment in screenprinting. It comes when you lay aside the squeegee and lift the screen to see that first, perfect print. The creative ideas, the planning, and the organization are all past. These stages took energy, effort, careful thought, problem solving, time, and attention—all undertaken in the hopes of a reward at the end. Ah! What a sweet reward that first print is! And the second! And the third! And the fourth, too. Each time, until you've printed them all. No other creative pursuit can promise that kind of thrill in such abundance.

The ability to make so many prints so easily is just one of the virtues of screenprinting. It is also a process that loves color and can produce vivid imagery in many versatile ways—you can print on practically any surface, including paper, fabric, glass, metal, and clay. And it is an accessible medium because the equipment and tools required are relatively few and inexpensive.

Perhaps these are the reasons screenprinting has held such a close association with many events in cultural history. How often has a poster been used to express a point of view? To protest? To announce an event? Screenprinting allows the artist to produce multiples without needing a printing press or an elaborate workshop; many posters have been created

in a basement or a garage for little expense. In the depths of the Depression in the United States, state-sponsored artists used screenprinting to document life during this bleak time. Governments throughout the world have exploited the medium for propaganda purposes, and political activists have likewise expressed their views on screenprinted signage. Posters in psychedelic neon colors that publicized rock concerts in the 1960s were brilliant metaphors for the changes that society experienced in that decade.

Screenprinting as we know it has a relatively short history. Fabric meshes were not attached to frames for printing until the early 1900s, nor were squeegees invented until that time. Despite its fairly recent development, the process

evolved from the ancient medium of stenciling, used extensively for artistic and commercial purposes in China and Japan as early as A.D. 500. Stenciling created some of the most intricate and detailed images that can be imagined.

Throughout the last century, screenprinting has been used for many commercial purposes, such as boxes and labels. Screenprinted fabric has long been used in the fashion and design industries for clothing and home décor such as pillows, curtains, rugs, bedding, and table linens. But artists have always been interested in the creative opportunities presented by the medium. In order to distinguish the art form from its commercial applications, Carl Zigrosser, curator of Philadelphia Museum of Art in the 1930s and 1940s, created the term *serigraphy* to refer to the fine art screenprint. The National Serigraph Society was founded in 1940 to promote the art of serigraphy throughout the world. Recognition of screenprinting as a fine art blossomed in the 1960s when Andy Warhol used large commercial screens to create his Pop Art images. Warhol's screenprints are now universally recognized and command millions of dollars on the art market.

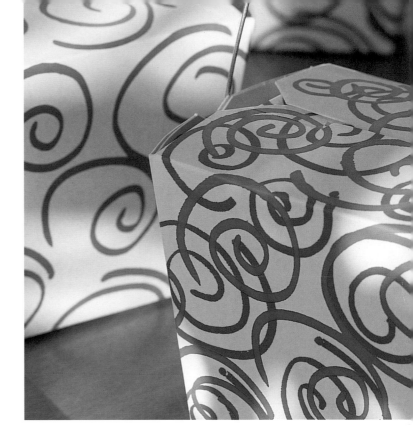

Simple Screenprinting will introduce you to the process of serigraphy, as well as offer advanced concepts for the exploration of the medium. The book focuses on using water-based inks in the home studio, where the artist and the craftsperson can create works based on the techniques and projects included here. Fine art imagery and works by contemporary artists provide inspiration for both the beginner and the expert screenprinter.

Screenprinting is so versatile you can achieve sophisticated results from simple paper stencils, or you can employ multiple techniques to create an intricate work of art. You can create stencils from drawing, painting, found imagery, text, photographs, or any combination of the above, so screenprinting can satisfy all of your artistic endeavors. May this book inspire you to discover this fascinating art form.

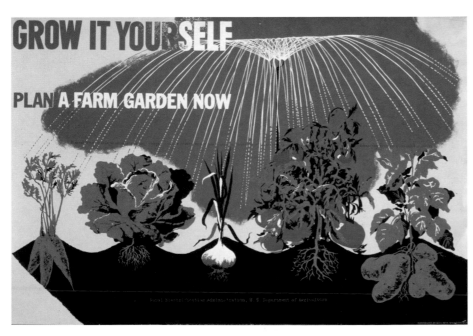

Depression-era posters such as this helped created interest in the fine-art applications of screenprinting.

Herbert Bayer, *Grow It Yourself, Plan a Farm Garden Now.* Work Projects Administration Poster Collection (Library of Congress). Courtesy of Library of Congress Photoduplication Services.

history of screenprinting

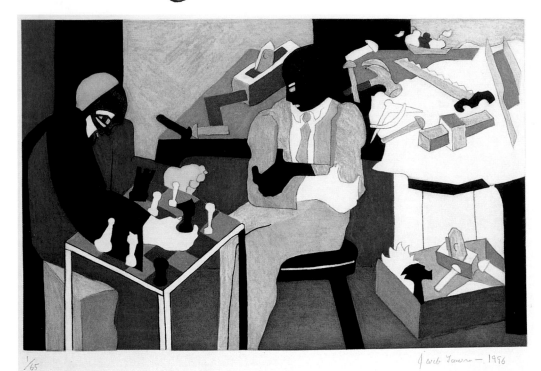

1/65

Jacob Lawrence, *Builders Playing Chess*, 1996. Serigraph. 19^1/$_2$ x 24^3/$_4$ in. (49.5 x 62.9 cm). Photography by Richard Nicol. Courtesy of The Walter O. Evans Collection of African American Art.

Ben Shahn, *Poet*, 1960. Serigraph. 39^3/$_4$ x 25^1/$_8$ inches (100.1 x 63.8 cm). Image courtesy of Davidson Galleries, Seattle, Washington. © Estate of Ben Shahn/Licensed by VAGA, New York, NY.

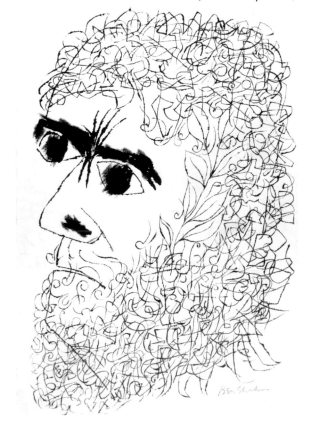

Screenprinting evolved from advanced forms of stenciling. The earliest recorded examples of stenciling are negative prints of the human hand, found in Paleolithic cave paintings dating from as early as 30,000 B.C. Primitive cultures typically used stencils made from common perishable materials such as leaves or animal skins. As civilization advanced, more sophisticated methods developed: in ancient Egypt, stencils were used to decorate tombs; the Greeks and the Romans employed stencils to paint murals and outline mosaics. It was the Chinese and Japanese cultures, however, that began to utilize the craft for production purposes. As early as A.D. 500, stenciling was used to reproduce images of the Buddha throughout China and to decorate bulk amounts of fabric in Japan.

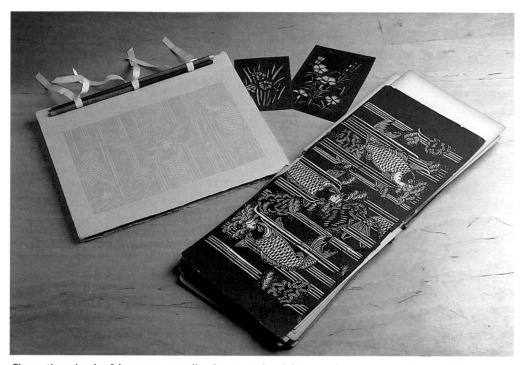

One of the famous textile designs from Marimekko. Maija Isola, *Unikko* pattern, 1965. Printed cotton fabric. Photograph by Rauno Träskelin. Courtesy of the Bard Graduate Center for Studies in the Decorative Arts, Design and Culture.

early japanese stenciling

Japanese legend credits the origin of stenciling to an elderly man who found inspiration in the intricate designs that an insect made in the leaves of a cherry tree.

By the sixth century A.D. the Japanese became innovators who transformed the primitive practice of stenciling into high art, adding techniques to print the isolated parts of a design which allowed for greater detail in the final product. These early stencils were a marvel of intricate cuts, complex designs, and technical achievements. Elaborate images of intertwined cranes, chrysanthemums, fish, geese, fans, butterflies, and turtles were cut by hand. Much of this imagery was related to ancient legends and stories.

The isolated (or floating) parts of the design were stabilized using an ingenious and almost invisible grid system. To hold these floating pieces in place, artisans developed a method by which individual strands of hair or silk fibers were set in place with glue and sandwiched between identical pieces of thin stencil paper. Registration marks were made by placing pinholes in precise locations.

Used as a method for adorning textiles, the technique of *katazome*, an early form of Japanese stenciling, advanced the craft by developing more durable stencils. Using stacked sheets of thin mulberry bark cured in tannin-rich persimmon juice, intricate images were carved, resulting in a series of near identical stencils. As paper became more readily available, up to 60 sheets of tissue-thin paper could be carved at one time, allowing for even more intricacy of pattern and consistency in production. Thick rice paste was applied through the stencil, with the rice paste acting as a resist to the indigo dye. When the paste washed clean, an image of the stenciled pattern remained.

The antique book of Japanese stencils, shown at the right, contains some genuine stencils from the 1800s, shown in the center. It was the source of the imagery used in the journal project shown at the left; the project is featured on page 96.

un moment
di libes.
Ne devrait-on
pas faire ac.
complir un
grand voyage
en avion aux
jeunes gens
ayant terminé
leurs études.

54

Henri Matisse, *Icare*, Plate VIII from *Jazz*, 1947. Pochoir. Collection of the Grunwald Center for the Graphic Arts, UCLA Hammer Museum. Gift of Mr. Norton Simon. Photography by Robert Wedemeyer. ©2004 Succession H. Matisse, Paris/Artists Rights Society (ARS), New York.

Although the *katazome* technique diminished with the increased popularity of woven fabrics, it regained its significance in the late sixteenth century when the ruling samurai class valued its fine craftsmanship. The grid of silk threads was eventually replaced by silk fabric stretched over a wooden frame, which allowed for the development of modern screenprinting.

stenciling to screenprinting

The more advanced Japanese techniques influenced the Europeans after these methods spread to the West through trade routes. Soon, these inventive processes were being used in the rapidly advancing European textile industry. Stencils affixed to silk may have been used in Germany and France by the late nineteenth century.

The evolution from stenciling to screenprinting was hastened in 1907, when Englishman Samuel Simon patented a screen based on the Japanese model of silk on a wooden frame. Just a few years later, American John Pilsworth patented a multicolor screen process to be used in the high-quantity production of advertising signs and point-of-sale materials. Inexpensive and readily available bolting cloth supported the hand-cut paper stencils.

Technological advancements followed rapidly, as specialized stencil film and light-sensitive photographic emulsion were introduced. The development of the squeegee eliminated the need to use stiff brushes to push the ink through the stencil. Screenprinting thrived as a commercial process by the 1920s, and it was particularly well suited to the textile industry.

screenprinting to serigraphy

Artists began experimenting with the expressive qualities of the medium in the 1930s. In Europe, there was an exciting period of collaboration between artists and textile manufacturers that continued throughout the century. In the United States, many artists were exposed to screenprinting in the federally sponsored arts projects established during the Depression. The term serigraphy entered the lexicon at the time artists were investigating the potential of creating fine art through screenprinting. Despite some years of serious pursuit by artists, it was not until the Pop Art movement of the 1960s that serigraphy was firmly established as an art form, when artists such as Andy Warhol and Robert Rauschenberg created a sensation working in the medium.

Stenciling, screenprinting's precursor, is still a popular method of artistic expression. Also called *pochoir*, French for stencil, fine art stenciling uses a brush to create an image through a template. Many fine art examples exist, including Henri Matisse's *pochoir* version of the Jazz Series, created after he finished the cutout collaged version of the series. The Applying Your Skills section begins with a demonstration of this technique on page 54.

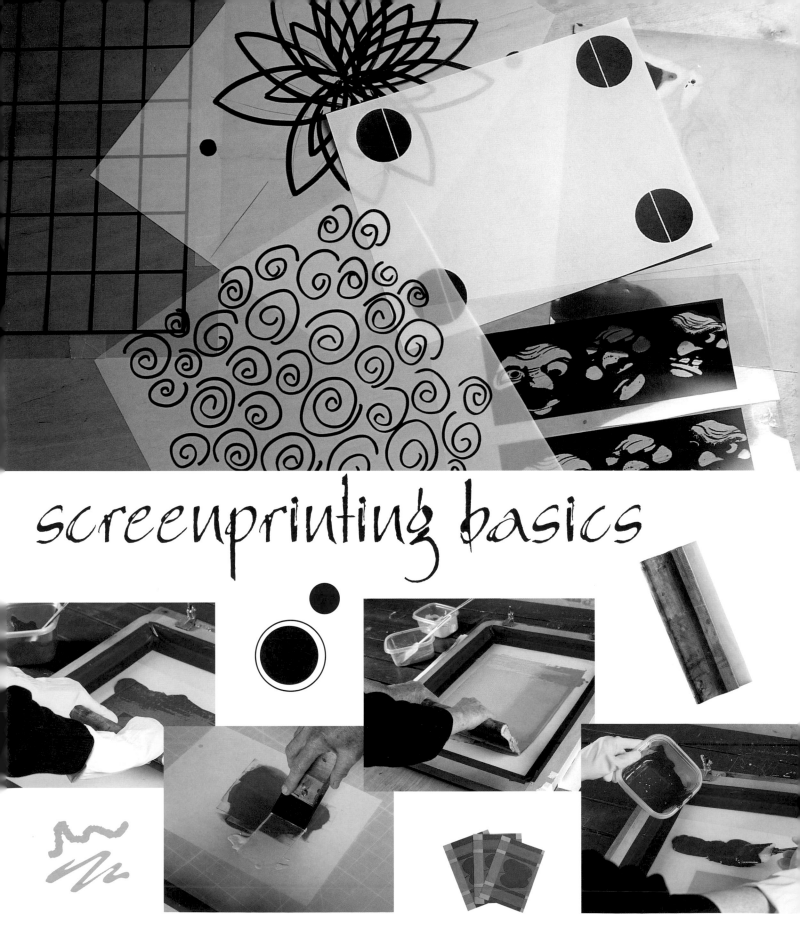

screenprinting basics

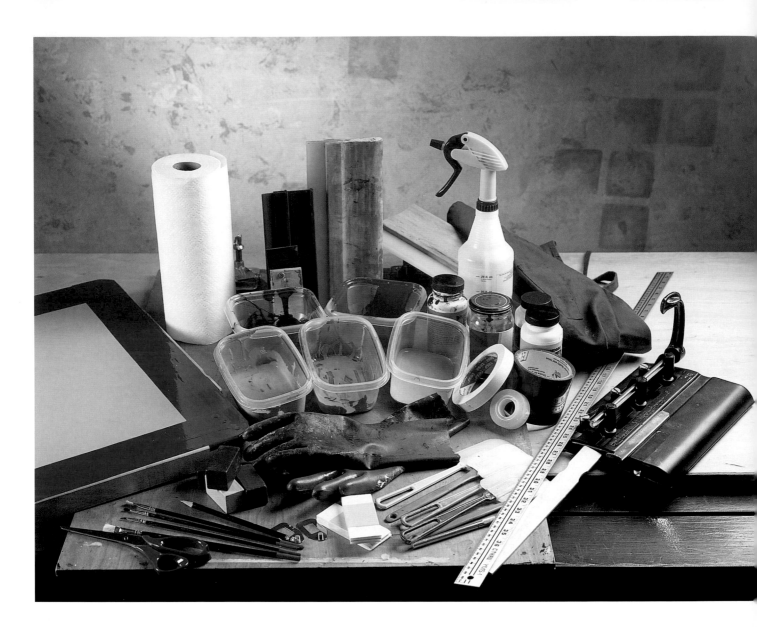

Screenprinting is an exciting, colorful medium that allows you to easily create your artwork in multiples. Also called serigraphy, screenprinting allows you to become a printmaker without a press; it happens by forcing ink through a design on a stencil attached to a mesh screen, producing an image on the paper or fabric underneath.

Screenprinting is a relatively young art form, although it evolved from stenciling, which has been known since ancient times. With a minimum of specialized tools and supplies and a basic workspace, you can begin exploring this simple type of printmaking.

gathering supplies

Screenprinting supplies are available from commercial screen-printing suppliers, mail order or Internet art supply sources, as well as many art and craft stores. The commercial supply houses offer the widest selection of high-quality materials, and the staff are especially knowledgeable about what they sell.

screen

While it's possible to purchase the frame, fabric, and other components separately and assemble your own screen, ready-made screens are easily available and cost efficient. They also have the added benefit of machine-stretched mesh, which provides more tension than you can achieve from stretching the screen by hand. Screens come in a variety of sizes, most often identified by the measurement of the inside dimensions of the frame, rather than the outside dimensions. An average-sized screen, say 20 x 24 inches (50.8 x 61 cm), is a good first choice because it is big enough to allow a range of print sizes, yet small enough to be manageable while you are learning how to work with it. Screens come with wooden or aluminum frames. Either works well, although a wooden frame offers an advantage because you can attach a movable drop stick to one side to serve as a screen prop while you're working underneath. Although you can prop up the screen on your shoulder, this moveable arm offers you enhanced mobility while you work.

Although screens were once made from silk (which is why the term *silkscreen* is still common), most are now made from polyester, available in two mesh types: *monofilament* and *multifilament*. Monofilament meshes are woven from single strands of thread and are generally better suited for printing on paper. Multifilament meshes are a weave of threads made from many strands twisted together. Multifilament meshes are generally used when working with textile inks and printing on fabric.

Meshes come in a range of sizes, with the two types of mesh being labeled differently. Monofilament mesh is measured by the number of threads in the polyester weave per inch or centimeter. Multifilament mesh is labeled with a series of Xs, indicating the strength of the mesh. With either type of mesh, a lower number indicates a coarser mesh, which means that the holes between the threads are bigger and more ink will be deposited during printing. A higher number indicates a tighter weave that can yield more detail in printing. Generally, selecting a monofilament mesh with 200 to 260 thread count will yield excellent results with water-based inks on paper. When working with fabric, use a multifilament mesh within a range of 10XX to 14XX. Depending on the consistency and brand of ink you use, you may be able to work with tighter weaves, yielding even greater detail.

Meshes also come in different colors, such as yellow, orange, or white. Those that are yellow or orange don't reflect as much light as the white fabric and thus are designed for the *photo-emulsion* method of making a stencil. Generally, the colored screens will have a higher mesh count to produce the detail expected in the photo-emulsion process. White mesh can be used for other methods of screenprinting that don't involve this photographic exposure process. You'll learn about all the different methods of creating stencils beginning on page 36.

squeegee

A squeegee is a long blade attached to a wooden handle used to spread the ink across the screen. Squeegees come in varying lengths, blade cuts, and flexibility. While you're learning, use a squeegee with a square polyurethane blade, the best for printing on paper and fabric. To determine an appropriate length, consider the inside dimensions of your screen. A squeegee should be at least one inch (2.5 cm) wider on each side than the image you plan to print. But it should also fit into the *well* (the interior) of your screen with a couple of inches (5 cm) of space on each side, so the movement of the blade isn't hampered. Flexibility refers to the softness or hardness of the blade and is measured according to *durometer*. Any midrange durometer will work well on paper and fabric.

As you become experienced with screenprinting, you may want to acquire several screens in different frame and mesh sizes, and squeegees of various lengths and blade cuts. The illustrations in figure 1 describe the uses of the differing blades.

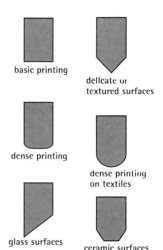

basic printing

delicate or textured surfaces

dense printing

dense printing on textiles

glass surfaces

ceramic surfaces

Figure 1. Different squeegee blades are designed for use on varied media.

backboard and supplies

You will attach your screens to a backboard when you work. Make a backboard from a sheet of lightweight wood or plywood with a smooth surface. It should be cut a bit larger on all sides than the screen you'll use.

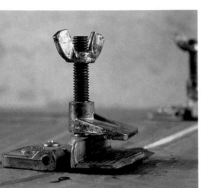

Specialty hinges are available from a screenprinting supplier and are sold in pairs. You can also use door hinges with removable pins, found in home improvement stores, but they are less versatile. Attach them to one end of your backboard to hold the screen tightly as you print. Hinges allow you to move the screen up and down without losing *registration*.

The drop stick serves as a moveable arm attached to your screen, so you can rest the screen in an upright position while you're working underneath. A paint stick, readily available from a paint store or home improvement center, works well as a drop stick.

sealing tape

Applied to both sides of a new screen before use, sealing tape prevents ink from seeping between the mesh and frame, which could cause unwanted ink transfer when you print.

register pins and supplies

Register pins are used in pairs as part of the registration process, which is how you determine that each color in your work aligns and prints in precisely the same place on each piece of paper. Register pins insure the proper placement of the paper on the backboard. The holes punched in your paper fit onto the heads of the pins and the paper is thus held in position while you're screenprinting. If you don't have enough excess paper to punch the holes or don't wish to punch holes in your paper, you can use registration tabs that attach to the paper, as shown on page 22. Registration methods can vary depending on your project and are discussed in more depth beginning on page 21.

An adjustable, manual office punch is ideal for registration purposes.

Purchase one sheet of medium-weight polyester film that is roughly the size of your screen. This reusable sheet performs an important role in the registration process, as you'll see when you learn about this procedure in more depth on pages 26 and 27. Here's an important tip: To insure the film lies properly on your backboard, purchase a flat sheet of polyester film rather than a piece cut from a roll.

Temporary spray adhesive is a marvelous aid in the printing process. Used in conjunction with registration pins, it will prevent the paper from lifting off the backboard as you print. Spray some on the backboard after removing the polyester film in the registration step. The spray will last through quite a few printings, and then you may need to add some more.

It can also be used quite effectively when registering fabric, when you'll often need to use a backing structure. The temporary spray adhesive keeps the fabric in its proper place on the structure.

A special note: Be sure to use temporary spray adhesive, not permanent spray mount. You must be able to remove the paper or fabric after you've printed on it.

stencil mediums

Common mediums used in making *direct* stencils, which are stencils prepared directly on the screen, include screen filler, screen drawing fluid, oil pastels, ordinary wax crayons, masking tape, and for special purposes, watercolor crayons. Screen filler is usually used as a block-out to fill in areas of the screen you don't want to print. You

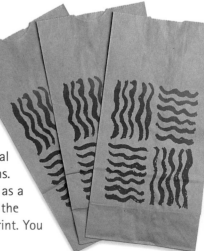

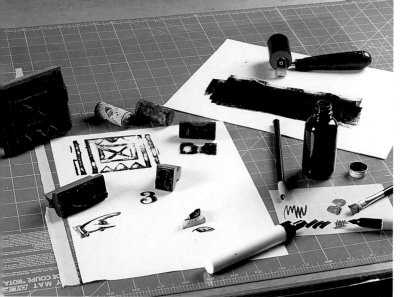

A variety of block-out mediums can be used to create imagery for photo-emulsion stencils.

apply the liquid filler with a brush or squeegee. Screen drawing fluid is usually applied with a brush and used in conjunction with screen filler to make a positive image. By varying the sizes of the brushes you use with either filler or drawing fluid, you can create wonderful painterly effects.

Oil pastels work as a positive medium, too, and can be used to get a nice, thick line quality or a rich, textural effect. An ordinary wax crayon can be used instead of an oil pastel, but it doesn't stick to the mesh as easily and is harder to remove from the screen. Masking tape is especially useful for creating hard edges and straight lines. Watercolor crayons are used in making monoprints, discussed more fully on page 50. As you become experienced in screenprinting, you'll discover other things that can be used in making direct stencils. And, experimenting might lead to some new and exciting results.

Freezer paper, available in many supermarkets, is ideal for use as an *indirect* paper stencil, a stencil prepared away from the screen and attached to it. Because it has a plastic coating, freezer paper doesn't wrinkle in contact with the water-based ink and it holds up well when making a large number of prints. Ordinary paper is not suitable for this purpose.

Various types of film can be used to create indirect stencils and are also used in the creation of photo-emulsion stencils. Other tools and materials, such as opaque markers, stamps, brayers, and relief ink can also be used in stencil making. You'll learn more about stencil mediums and techniques beginning on page 36.

ink and related supplies

One of the wonderful advances in screenprinting is the recent development of water-based inks that are of equivalent quality to traditional oil-based screenprinting inks. Oil-based inks have always presented health and environmental concerns, especially since toxic chemical solvents like mineral spirits and lacquer thinner must be used for cleanup. Many water-based inks are entirely nontoxic and cleanup can be done with water. While the processes used with oil-based inks are the same or similar to the processes used with water-based inks, the materials are quite different. All of the inks used in this book are water-based, so be sure to use them in conjunction with the projects.

A wide variety of excellent water-based inks are available from screenprint suppliers and art supply stores. For printing on fabric, be sure to select inks that are marked for textiles; ink intended for paper and ink intended for fabric are not interchangeable. Start with the primary colors—red, yellow, and blue—as well as black and white; these inks can be mixed to obtain most colors you may desire.

You'll also need to purchase transparent base, which serves a dual function. A little transparent base is always mixed into the ink to improve its printability by making the ink more responsive to the process when you're printing. The amount to mix in depends on the brand of ink you use and will be indicated on the label or in the instructions that accompany it. Also, transparent base (as implied by its name) becomes

beautiful transparent ink when tinted with a little color. Depending on the brand of ink you select, you may need retarder, which is mixed into the ink to prevent it from drying in the screen while you're printing. (For some ink brands, water serves as a retarder.) Some inks require a special cleaning agent; check with the supplier about whether you'll need this with the inks you choose.

additional supplies and tools

Plastic spatulas are great all-purpose tools used to mix inks and to move ink on the screen during printing.

Plastic containers or glass jars with wide mouths and tight-fitting lids are ideal for mixing and storing inks.

At some point, you will need masking tape, clear tape, foam core board, and absorbent paper towels. You will probably want to wear protective gloves when you're handling ink or cleaning up, as well as wear a work apron while you are screenprinting. Get a couple of plastic scrub brushes to prepare new screens and use during cleanup. When you work with paper, you'll likely need a craft knife, a cutting mat, a pair of scissors, a paper cutter, or any combination of these tools.

paper or fabric selection

The size and the type of the paper you select will be determined by the nature of your project, of course. Usually, it is good to work with paper that is at least as heavy as card stock so the paper does not warp in reaction to the ink, but screenprints can be printed on almost any paper. If you are printing a work of art, or any project you want to preserve over time, you will want to select a quality acid-free paper that is made to resist deterioration, yellowing, and spotting. This means choosing *archival* papers, which are sold at most art stores as well as some craft stores. Archival paper has a definitive front and back due to the way it is made. If you can't easily see the difference, look for the watermark, which is most easily visible on the back of the sheet.

Many kinds of paper can be used successfully in screenprinting, including those shown in these photos.

Fabrics in varying weights and textures are suitable for screenprinting.

A typical paper size is 22 x 30 inches (55 x 76.2 cm), which might tear down to two or three sheets, depending on the size of the project you plan to make. Be careful to choose sheets of paper that aren't dinged, marked, creased, or damaged at the corners. Likewise, handle the paper carefully as you work with it so it remains pristine. Paper should be stored flat, away from dust, dirt, sunlight, and water.

When you're choosing paper, consider the paper's surface quality or *tooth*. Usually, papers with a smooth surface are best because they receive ink in a consistent manner. The roughness of heavily textured papers can inhibit the successful transfer of ink when printing.

The same quality is also seen in fabric; you can print on almost any weight of fabric, but a smooth surface yields a more consistent layer of ink than a highly textured one. You should probably avoid printing on fabric that has an open, loose weave, as there may not be enough fiber surface to produce a satisfactory result.

assembling the printing unit

In anticipation of your first screenprint, prepare the screen and assemble the backboard.

prepare the screen

Begin by applying sealing tape to both sides of the screen along the seams where the mesh and frame meet, starting with the well side first. (The flat side of the screen is called the back or the bottom.) Use pressure to tightly seal the tape to the frame and remove as many air bubbles as possible (photo 1). This process can sometimes be a bit awkward and a few wrinkles may be unavoidable. Compress them as much as possible. Seal the inside corners with a square piece of tape slit halfway down the middle, maneuvering the piece into the corner and lapping the slit ends over each other (photo 2).

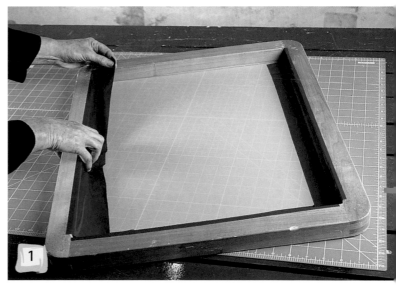

1

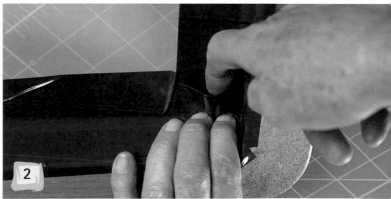

2

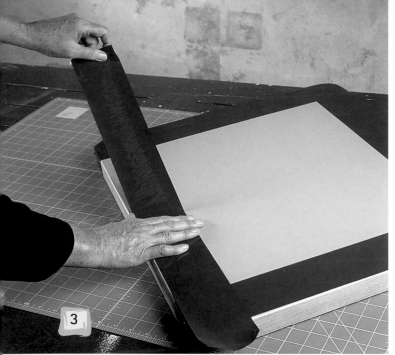

When you've finished taping both sides of the frame (photo 3), run your thumbs along the tape on both sides to assure a tight seal over the mesh (photo 4). A tight seal will help keep the tape in place through many printings. As the tape works loose with use, you can replace it.

degrease the screen

Before you use a new screen, it must be degreased and roughened. At the sink, apply a little household powdered cleanser and water to both sides of the screen. Position the screen upright under your arm, holding a brush in each hand, and scrub both sides of the screen in a circular pattern, like playing a harp (photo 5). If you keep even pressure on both sides of the screen, it will eliminate the danger of stressing the screen's tension so much that the fabric snaps and breaks. This, of course, would ruin your screen.

attach the hinges

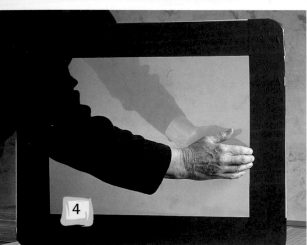

Now attach the hinges at the end of the backboard. They should be centered and about 18 inches (45.7 cm) apart. The drop stick should be screwed into one of the long sides of the screen, about a quarter of the distance from one end (photo 6). The drop stick should be loose enough to move easily when the screen is attached to the backboard, as shown in figure 2.

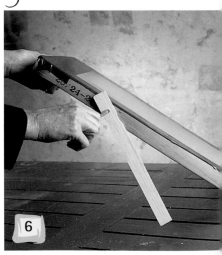

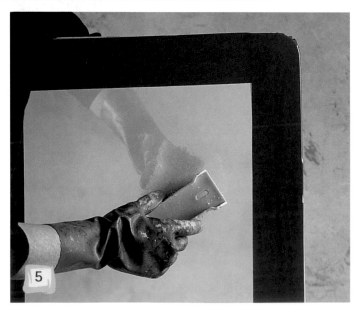

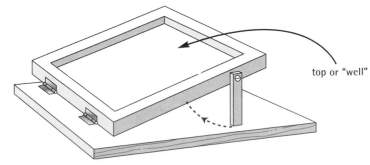

top or "well"

Figure 2. Be sure the drop stick swings freely when you screw it into the frame of the screen.

prepare for cleanup

Organize your cleaning area, because each screen has to be washed out immediately after printing or the ink dries and becomes really difficult to remove. A large industrial sink is ideal, but an infrequently used shower stall or bathtub can work. You'll also need water under pressure, which can be created with a simple spray nozzle. Attachable hose/spray nozzle units are available in most home improvement stores. A true pressure washer makes quick work of the cleaning process.

dispose of wastewater properly

Though water-based inks are far more environmentally safe than oil-based inks, some brands might contain toxic ingredients, although these ingredients in the water-based inks are much milder than those contained in the oil-based inks. Emulsions are generally the most toxic materials you'll use, because of the chemical ingredients necessary for developing the photographic image. Most emulsion removers have toxic chemical ingredients as well, although non-hazardous products are available. As water-based screenprinting materials evolve, more nontoxic options will be developed.

You can look at the label of the product to determine whether it is nontoxic or not. In the United States, "Conforms to ASTM D 4236" means that the product is nontoxic. (The term "AP" or "nontoxic" might also appear if its manufacturer belongs to a voluntary group whose members use this rating system). Products in the United States that contain toxic ingredients are required to provide health information on a Material Safety Data Sheet (MSDS), which is provided by the manufacturer upon request. In Europe, the notation "CH-BAGT T" (*sans classe de toxicite*) means the product is nontoxic.

Screenprinting does produce wastewater, but the amount generated in a home studio is minimal compared to a commercial operation. Generally, if your wastewater is emptied into a drain that leads to a municipal sewer system, this water can be safely treated at the sewer plant. Wastewater, though, should not be dumped directly on the ground, where it will contaminate ground water. If the products you are using do contain some toxic ingredients, read and follow the manufacturer's instructions for disposal of wastewater. Please be environmentally responsible.

learning to print

Screenprints are created one layer of color at a time. Screenprinting works by forcing ink through a screen as you pull a squeegee across it; the areas you don't want to print are blocked out by a stencil. Although there are a variety of stencil methods, the paper stencil is perhaps the best one for your first attempt at screenprinting. Surprisingly simple, this method can nevertheless yield quite sophisticated results. A paper stencil allows you to print solid shapes of color, one color per stencil. Depending on your image, two to four colors are a good number for a first screenprint.

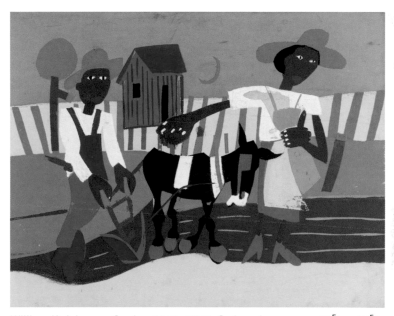

William H. Johnson, *Sowing*, 1940–1942. Serigraph on paper. $11^5/_8$ x $17^5/_8$ in. (29.5 x 44.8 cm). Photography by Smithsonian American Art Museum, Washington, D.C., U.S.A. Gift of Mrs. Douglas E. Younger. Smithsonian American Art Museum, Washington, D.C./Art Resource, NY.

make a paper stencil

Before producing your first paper stencil, draw an image to scale on tracing paper and designate color areas. (See the discussion about color on pages 34 and 35.) Next, cut a piece of freezer paper an inch (2.5 cm) or so larger than the inside dimensions of your screen. Turn your drawing over so you'll be working with the reversed image. Use carbon paper to transfer the outlines of the first color area to the center of the piece of freezer paper, working on the paper side, because you can't draw on the plastic-coated side. With a

sharp craft knife, cut away the area you wish to print (photo 7). Cut cleanly and don't cut past the corners. (Mistakes, however, can be quickly repaired with small pieces of cellophane tape on the paper side of the freezer wrap, as shown in photo 8.) Just that easily, your first stencil is ready.

attach the stencil

Place the screen on a tabletop with the back of the screen facing up, well facing down. Center the cutout areas of the stencil on the back of the screen, making sure that the plastic side of the freezer wrap is facing down, toward the screen, so your image isn't printed in reverse. Use a few short pieces of masking tape to loosely secure your stencil to the screen, overlapping the edges of the screen (photo 9). If any open areas remain that you don't want to print, you can cover them with strips of freezer paper overlapping the edges of the stencil (photo 10). Tape the freezer paper strips to the stencil in a few places and to the outside of your screen, just secure enough so everything stays in place when you turn the screen over. Because the ink will hold the stencil in place after the first squeegee swipe, keeping the tape to a minimum is best because it allows the paper a little freedom to attach to the inky screen without wrinkling.

prepare the paper

Even if your creative goals are to screenprint on fabric, it is best to try your first print on paper to simplify the learning process. First, decide on your *edition* size—the number of prints you'd like to make. Add one sheet for the registration guide, plus a few more sheets in case you make mistakes as you print. (Even the most experienced screenprinters occasionally make mistakes.) Tear or cut the sheets to the appropriate size, plus two or three inches (5 to 7.6 cm) on one side to accommodate the registration holes. (You'll tear or cut this end off after you finish the last color run.)

If you are working with a good quality paper, it is customary to tear the paper to size rather than cut it. You can do this by laying a metal straightedge (that is longer than the paper) along the tear line. Applying pressure against the straightedge with one hand, use your other hand to slowly tear away the excess paper by pulling it toward you, against the straightedge (photo 11). Use the hole punch to put two widely spaced holes on the registration side of each sheet

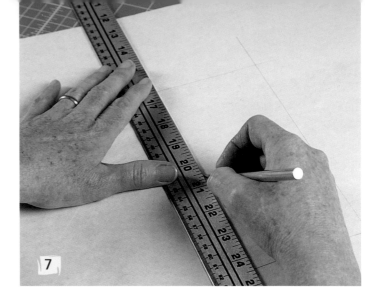

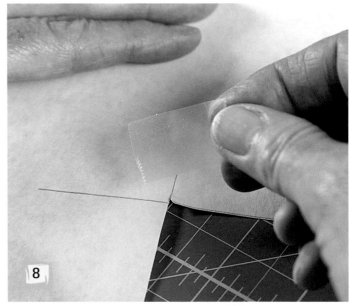

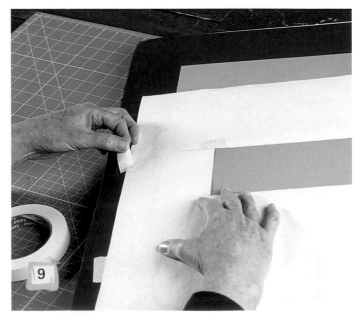

(photo 12). It is important that the holes be in exactly the same place on each sheet of paper. Lay the papers in a pile, front facing up. (As you handle the paper, be careful not to flip some sheets over, causing the registration holes to be misplaced in the next step.)

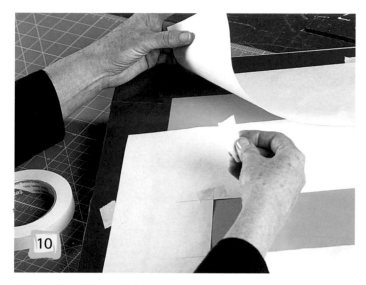

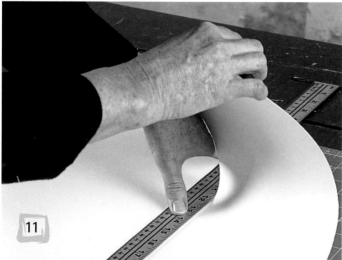

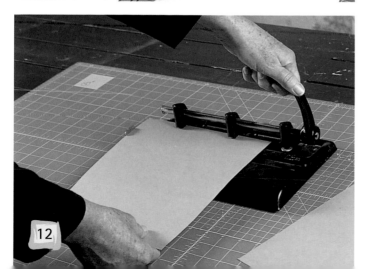

Explore Color and Design

Color—whether bold or delicate and whether used as a strong element in your work or used sparingly—is integral to the success of your art or craft. Experimenting with color choices and combinations is a very useful stage in bringing an idea to a successful reality. Much can be learned about color and there are many excellent resources to look to in gaining that knowledge. To begin, visit your local library.

The library is also a great place to research how things look. When creating representational images, finding an accurate picture or drawing in the library will help fill in the important details you may not recall from memory. Even when working with abstract imagery it is often important to have an accurate sense of the real thing in order to determine how you want to distort or abstract it.

Having difficulty coming up with an idea for your project or artwork? Spend a few hours at the library looking at books and magazines. Visit the art section and also the sections that have books about your special interests. Take your sketchbook and note in words or thumbnail sketches whatever catches your fancy. Later, you can use these notes to develop creative ideas.

the registration concept

Registration is a method for making sure you print in exactly the same place on each sheet of paper or each piece of fabric, and that the colors in each subsequent color run align as you print. There is a simple method of registration that works beautifully for almost any project; it is helpful to understand the process before you start. It begins with a first print on clear polyester film. Then you place a guide sheet of paper under the film, so the image on the film is superimposed over the paper. You can move the paper

around under the film until it is situated where you would like the image to print on it. Then you mark this placement exactly for the printing process. You can use various methods to affix the paper or fabric in place or to mark the appropriate placement on the backboard. Each time you add a new color to your project, you have to repeat the registration process. The following are some guidelines for registration; select the method that works best with your project. Methods for registering fabric are included too, if you are interested in working in that medium after you have mastered the basics of screenprinting.

registering paper

For precise registration, register pins are best. These are a pair of small metal rectangles with raised notches on which you can fit paper that has registration holes punched in one end. If you need precise registration on paper that doesn't allow extra room for punched holes, you can use adhesive plastic tabs with holes. They should be attached in exactly the same place on the underside of each of the papers. There are also plastic registration tabs that snugly hold the edges of the paper in place (photo 13).

Some projects require only a loose registration guide. You can provide simple guidelines for the placement of the paper used in these kinds of projects by placing masking tape on the backboard (photo 14). When you register the first sheet of paper under the polyester film, align masking tape along three sides of the sheet. Then, place each sheet of paper in your edition within these marks. The tape can be removed after you've finished printing. (The example illustrated here in photos 14, 15, 16, and 17 shows simple registration marks for two different paper items. This project can be found on page 56.)

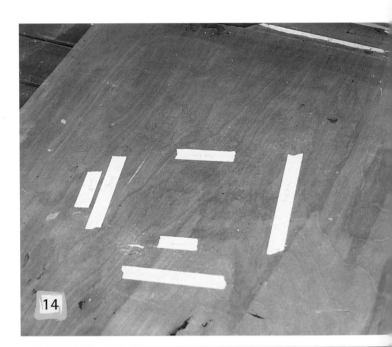

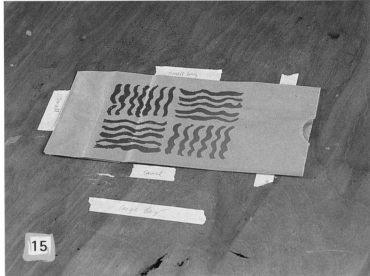

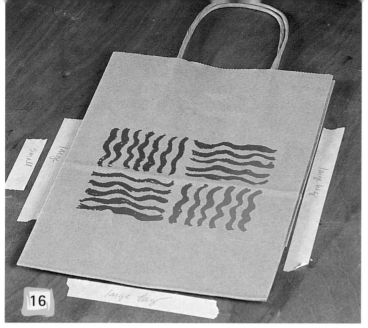

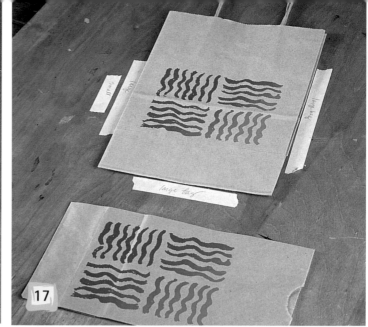

registering fabric

The key to printing successfully on fabric is to adhere it to a stiff backing to immobilize it (photo 18). Card stock adhered with a temporary spray adhesive, or freezer paper affixed with a warm iron, works well for fabrics with less give. Sheer silks and other slippery, lightweight fabrics need a much stronger backing, such as a piece of foam-core board.

Identical backing structures must be made for each piece of fabric to be printed and the fabrics must be adhered to the backing structures in identical positions so perfect registration can be maintained throughout the edition. When you are working with an item like a T-shirt, slip the structure between the front and the back and wrap the fabric around the structure as necessary (photo 19). In addition to aiding registration, this structure protects the second layer (i.e., the back of the shirt) from unwanted ink when you print (photo 20).

The backing structure itself can often be used for registration. If the structure is made from a paper product, cut it longer than the project and punch registration holes at the open end. If the structure is foam-core board, lay masking tape strips on the backboard along three sides of the foam-core board when it's first registered, similar to using masking tape for paper as mentioned on page 22. The backing structure is also very helpful when the fabric is moved after printing—it will help keep the fabric from folding over on itself and smearing the wet ink.

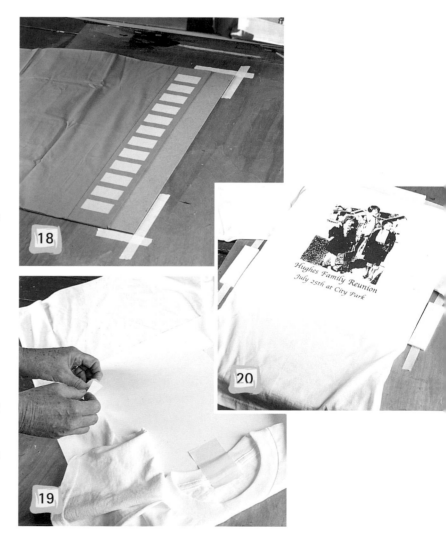

It is also helpful to place masking tape strips on the fabric to indicate where the image should print, in addition to applying tape strips to the backboard to indicate the position of the backing structure.

prepare the registration guide sheet

Sometimes you can register by eye, because the image you want to print doesn't require exact registration and you can easily see where the first and subsequent colors should go on the paper or fabric. But when you are printing an image that has abutting or overlapping areas of color that must fit perfectly in place, you'll want more exacting registration that is facilitated by making a guide sheet. The guide sheet indicates the placement of the images to be printed. (This concept applies to fabric projects, too.)

In the example shown here, the guide sheet indicates borders and the fold line with a series of pencil marks (photo 21). This will let you easily align the colors by eye as you print. (For a more complicated project, you can tape the original scale drawing in place on a sheet of the paper on which you'll print; you will remove the drawing prior to printing. There are several examples of this technique in the book: in Enhancing Your Skills, on page 49, and in Applying Your Skills, on pages 106 and 109.) You may also measure and draw lines for a border to the image, if you want one. Punch registration holes in this sheet at the same time you punch the others. After you have prepared the registration sheet, lay it on the top of your pile of papers to be printed, ready to go. The guide sheet will be the first sheet to position under the polyester film when you are determining where to place the register pins.

mix the ink

When mixing colors to get the shade you want, start with the lightest color. Mix small amounts of the darker color (or colors) into it, adding more of the darker color until you're pleased with the shade. Because darker colors influence lighter colors more forcefully, this helps prevent having to mix more ink than you want in order to achieve the desired shade. Likewise, if you want to achieve transparent ink, begin with transparent base and add color a little at a time. Although it might initially be difficult to get the hang of mixing the right transparent color, experience will result in the ability to achieve wonderful effects.

Once you've got the desired color, add transparent base so it makes up 10 to 60 percent of the mixture, depending on how transparent you want the color to be; retarder should be added last, to a proportion of approximately five percent. (You might use water as the retarder, depending on the brand of ink you choose.) Stir well to guard against streaks when you print.

proof the colors

It's always a good idea to proof your colors before you print by creating a test strip, because looking at ink in a container gives you only part of the information you need to know about how it will look on paper. Until you print, you won't know how transparent the ink is, or how it will cover other colors you've already printed. It's worth taking the time to print test strips of each of the inks after mixing them, so you can make adjustments to opacity or shade.

Printing a test strip is easy to do. Before setting up for the actual print run, lay a scrap of the paper you'll be using under the screen. (You don't need to register it.) Then lay a little of the first ink somewhere on the screen and pull the squeegee through it so it prints on the test strip. Do this with each color, making sure to layer the colors as you will in the actual print (photos 22 and 23). Clean the screen after finishing the test strips.

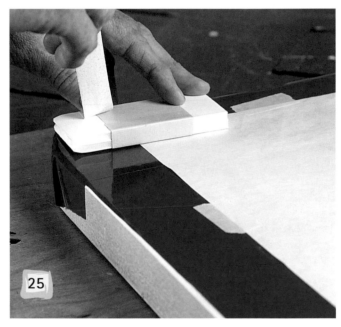

attach the screen to the backboard

Now that your screen, paper, and ink are prepared, you are ready to attach the screen to the backboard and assemble around you the things you will need as you print. Clamp the screen to your backboard (photo 24), making sure the grip is very tight; you can attach the screen either vertically or horizontally, whichever orientation best suits your project. Now make and attach the corner lifts, which will elevate the screen slightly when you work. Corner lifts help keep the screen from having contact with the print except when the squeegee is being pulled across the screen. If the mesh rests on the fresh print anywhere, it will be obvious when you raise the screen: it will leave a telltale curved texture where it was touching the new ink.

Make two corner lifts by cutting four rectangles of foam-core board, approximately 1 1/2 x 3 inches (3.8 x 7.6 cm). Use masking tape to make two pairs of rectangles, taping two pieces of foam-core board together like sandwiches. Tape them to each of the corners of the screen on the end that will not be held by clamps (photo 25).

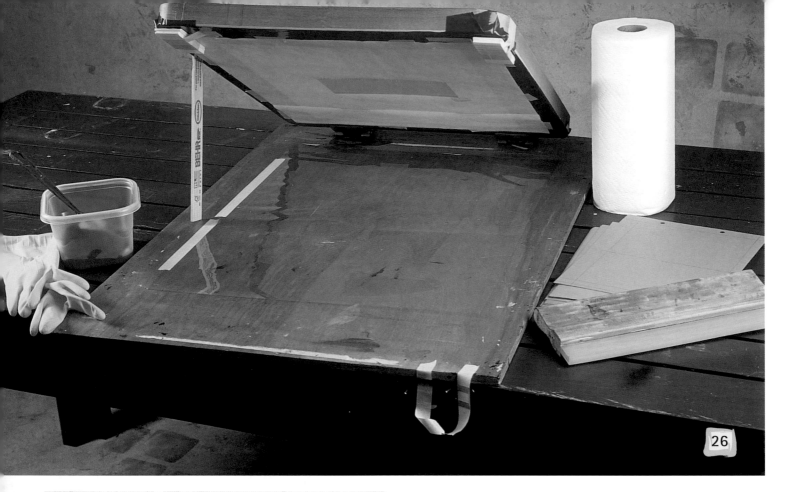

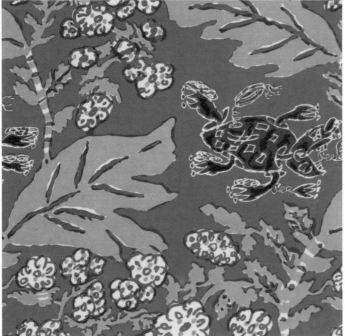

Will Stokes, Jr. *Leaves and Animals* (detail), 2003. Hand screenprint on paper-backed cotton sateen. Wallpaper width: 50 inches (127 cm). Created in collaboration with The Fabric Workshop and Museum. Photography by Aaron Igler. Courtesy of the artist and The Fabric Workshop and Museum, Philadelphia.

Lift the screen and place the polyester film on the backboard, centered below the image on the stencil. Attach it securely with masking tape along the far side. Attach the end of each register pin to the middle of a short strip of masking tape. Until you need the register pins, hang them from the edge of the backboard or the tabletop. Have some paper towels on the ready in case your hands get inky during the printing process. Put the jar of ink and spatula within easy reach. Place the pile of paper nearby. Now you are ready to print (photo 26).

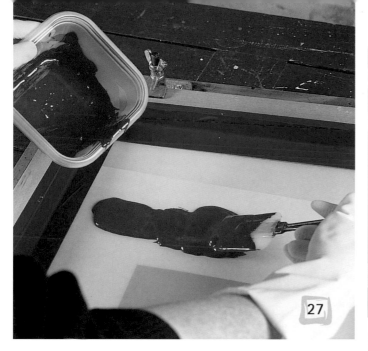
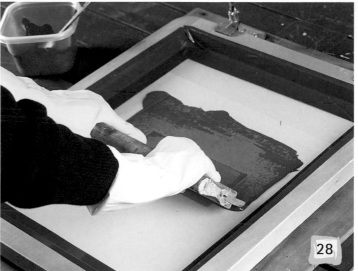

make your first screenprint

The first print will appear on the polyester film, to show you where to position the paper when it is time to register the image. Using the spatula, lay a ribbon of ink at the top of the screen (photo 27). Position the squeegee just above the ink. Hold it with both hands angled toward you at a 45-degree angle. Using downward pressure, pull the squeegee quickly toward you at an even rate (photo 28). Keeping the squeegee in place, lift the screen slightly with one hand and, using the other hand, push the squeegee back toward the far side of the screen, distributing a layer of ink over the open areas of the stencil (photo 29). This movement, called a *back flood* or a *flood stroke*, prepares the ink for the next print and helps keep the ink from drying in the screen. A back flood should be completed after each print pull of the squeegee. (This will become second nature after a while.) Lean the squeegee against the back side of the frame or lay it aside when you have finished printing. Raise the screen and check to make sure you have printed onto the polyester film (photo 30). You may pull the squeegee again for another print stroke if coverage isn't complete; be sure you always pull in the same direction when you print. When the print is satisfactory, remember to complete a back flood.

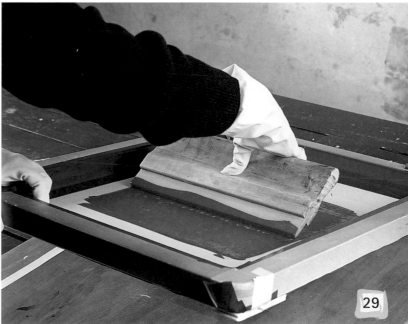

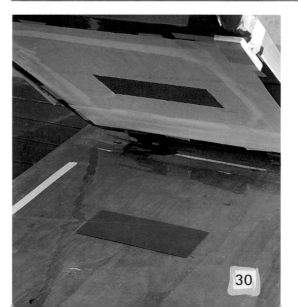

Lift the screen and let it rest on the drop stick. To register your print, position the registration guide sheet under the image you just printed on the polyester film (photo 31). Once you've placed the guide sheet under the film and the image is superimposed on the paper where you would like it to print, slip the register pins into the two holes of the guide sheet, being careful not to move the paper, and tape the pins securely to the backboard (photo 32). You can now detach and set aside the polyester film, because you'll not need it again until you are ready to register the image for the next color run. During the cleanup process after printing each color, clean the film so it's ready for its next use. Remove the guide sheet and lightly spray some temporary adhesive on the backboard to hold the paper in place when you're printing. (You might need to reapply the adhesive once or twice during the printing process, depending on how many prints you are making.) Put a piece of paper on the register pins. Pull the squeegee across the ink to make your first print onto paper (photo 33).

Print the remaining sheets of paper, one at a time, and lay them out to dry on a nearby tabletop or the floor around you. They'll dry quickly, so by the time you clean up from one color run, you'll probably be able to set up for the next one, if you like.

Here are some other tips about printing that you should remember:

⚡ Don't turn the squeegee around for the flood stroke; simply lift the squeegee and place it on the other side of the ink you have pulled toward you during the print stroke.

⚡ Between print runs, lean the squeegee inside the well, upright against the far end of the screen, or lay it on the worktable on newsprint.

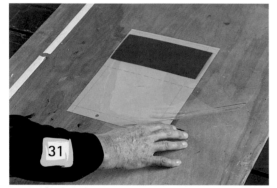

⚡ Use the spatula to scoop ink from the sides inside the well and to scrape ink from the squeegee so you can return ink to the right place on the mesh.

⚡ You may also add a ribbon of fresh ink between print runs, if needed.

⚡ After a pull, be sure to check your work by raising the screen and looking at it, but do not remove the paper from the register pins until you are satisfied with the quality of the print.

⚡ With practice, you will be able to print beautifully with one or two swipes of the squeegee. Over time, the sequence of printing movements will come naturally and you'll develop your own style and rhythm.

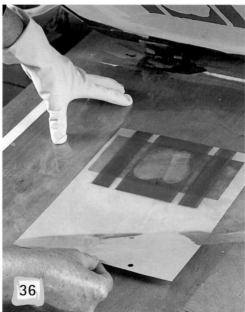

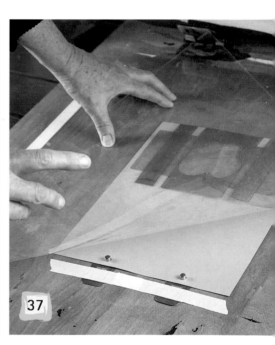

add a new color

One of screenprinting's great attractions is its ability to produce color imagery in so many versatile ways. When you add a second color to a project, you repeat the registration process for each subsequent color. Each new color requires a separate stencil that is used on a clean screen.

After you've attached the stencil for the next color to the screen, place the clean piece of polyester film on the backboard, just as you did for your first print. Pull a print in the second color onto the polyester film (photos 34 and 35). Then, place the registration guide sheet under the film to determine the placement of the next color (photo 36). If you don't need exacting registration, a print from the first color run can often be used instead of the guide sheet. When you've arranged the registration guide sheet or print to your satisfaction, carefully attach the registration pins (photo 37) and then remove the polyester film as before. Continue screenprinting with the second color, one print at a time (photo 38). Repeat the registration

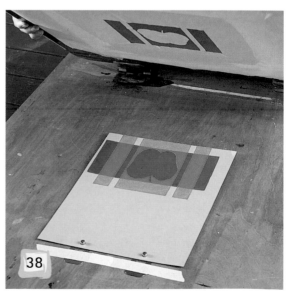

procedure for each color in your project. Let the prints dry flat. You can also hang prints to dry, by rigging a simple line with taut string. Use clothespins or bulldog clips to hold the prints as they dry, as shown in figure 3.

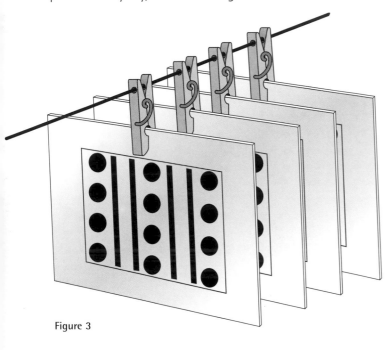

Figure 3

complete the process

When you have printed the final color of a work on paper, tear or cut off the extra paper you may have used for registration. Look through the prints and set aside any that haven't printed to your satisfaction. Review each print in the imperfect pile to look for prints with only minor flaws. Working with the inks left over from the print runs, you can use a small brush to make corrections in any areas that are missing ink. After using the brush, very carefully blot the area with newsprint to smooth the surface of the repair. If you find small ink marks in the border or other unwanted areas, you can often eliminate these by first removing as much as possible with a white plastic eraser and then gently scraping the surface of the unwanted ink with a razor blade. This process can be repeated until the area is clean. Because you are also removing a thin layer of paper, be careful and exert delicate pressure during this procedure.

Count the number of good prints to determine the final edition size. Each fine art serigraph should be signed by the artist and numbered to indicate its sequence in the edition (i.e., 10/100, meaning the tenth print made in an edition of 100 prints). The year in which the print is made should be indicated as well. If your print has a bottom border, this information should appear just below the image in the unprinted border. The title of the work should appear at the left; the edition number in the center; and your signature and date at the right. Always sign in pencil. If your print has no border (this is called a *bleed edge*), you can still sign along the bottom, unless you think it will distract too much from the image. In that case, sign the back of the print along the bottom, in the same manner as just described.

The guidelines for signing works on fabric are much more flexible than those for paper and depend on the nature of the piece. You might integrate your signature and the date into the piece itself, for example. When working with fabric, the ink may need to be heat set after it has dried so it remains colorfast when you wash the fabric. Check the instructions that accompany the textile ink for more information on setting the ink.

clean the screen

Clean the screen right away after printing or cleaning it will become quite a chore. Use the spatula to scrape any excess ink from the well of the screen (photo 39) and return it to the jar. Then use a paper towel to wipe out as much of the residue as you can. Gently pull the paper stencil and tape from the screen and discard (photo 40). Detach the screen from the clamps and pull off the foam-core board squares; keep them for future use.

Take the screen to your cleaning area and rinse out the ink with cold water (photo 41) or use the cleaning product suggested by the ink manufacturer. You can use scrub brushes on both sides of the screen, moving them in a circular fashion as when you degreased the screen. Use water to clean the squeegee, spatula, and any other tools you may have used. Be sure to read the instructions that accompany the ink you buy, as the manufacturer may suggest a different method or require a particular product to remove the ink from the screen. Remember to be aware of the environmental impacts of the products you are using and follow the proper procedures for their disposal.

label and store inks

Typically, you'll have ink left over after printing. Save it! You can use the ink again another time or use it when mixing a new color. Remember that it already contains a little transparent base.

While you can see the color of the ink by looking at it in the container, you can't tell how transparent it will be when printed. A good way to record that information is to label the container with

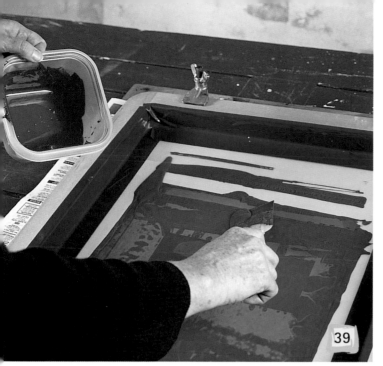

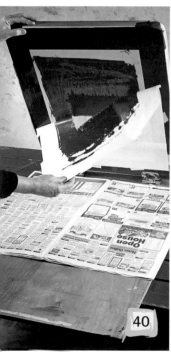

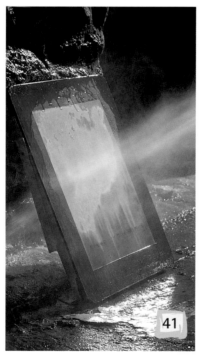

40

41

39

Common Printing Problems

Beginning printers commonly encounter these four printing problems:

1 *Ink dries in the screen while you're printing.*
This can happen if the printing process is taking a long time. Sometimes, you can push the dried ink through the screen by applying extra pressure when you pull the squeegee across the screen. If that doesn't work, you may need to spot-clean the problem area of the screen by rubbing damp paper towels over the area from both sides of the screen. If you're working with a paper stencil, be careful not to wrinkle it. If this doesn't solve the problem, you'll have to remove the stencil, clean the entire screen, and begin again.

2 *Ink bleeds onto the print under the edges of the stencil.* This can happen from applying too much pressure as you pull the squeegee. Use a dry paper towel to clean the ink residue from the underside of the stencil. Wipe from the stencil into the open areas, moving to a clean part of the towel as it gets inky. Continue printing after the ink has been removed.

3 *Ink has uneven color or streaks.*
This usually happens because the ink hasn't been mixed well enough or because the squeegee or screen hasn't been cleaned sufficiently after prior use. You can scoop the problem ink out of the well of the screen and off the squeegee, wipe the squeegee or the area of the screen that is problematic, and continue.

4 *Squeegee doesn't make contact with the paper.*
This happens because the hinges hold the frame too high above the backboard. The mesh will relax with use and the problem will disappear; for now, attach a sheet of foam-core board to the backboard to raise the printing surface.

a swatch of printed paper cut from a bad print. If it's a transparent color, make sure you cut an area where the color overlaps another so you can be reminded of the level of transparency. Store inks in an airtight container. While the inks may dry somewhat, you can usually revive them with a little transparent base, retarder, or water, depending on the brand.

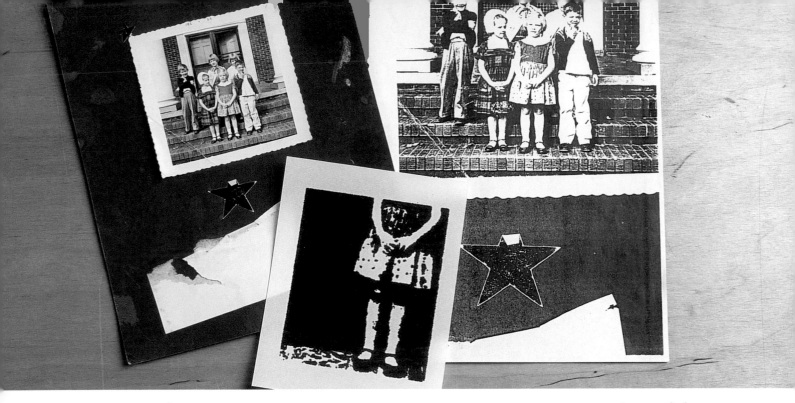

enhancing your skills

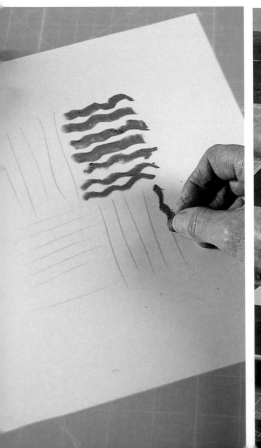

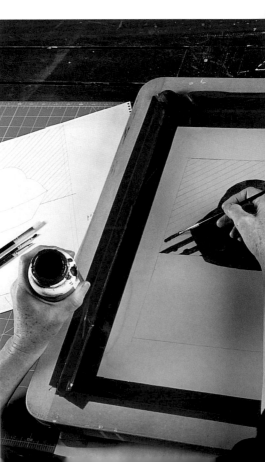

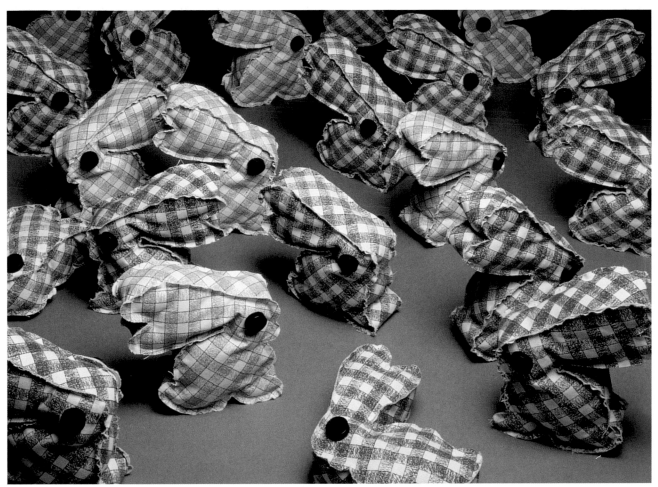

Claes Oldenburg, *Calico Bunny*, 1997. Pigment on canvas, polyester, painted wood, and metal. 13 x 10 x 6 in. (33 x 25.4 x 15.2 cm) each. Edition of 99. Printed at The Fabric Workshop and Museum, Philadelphia.

One of the strengths of screenprinting is its versatility. You can use simple paper stencils to produce exciting projects, but you can also experiment with a combination of different stenciling techniques to expand your expertise. Create your own artwork right on the screen, use your own photographs or computer-generated images, add found objects, and utilize photocopies and copyright-free imagery to produce original works of art. The possibilities presented by screenprinting are virtually endless. Here are some strategies for creating a project, from conception to completion.

developing an idea

Every piece of art—from Henri Matisse's *Icare* Plate VIII from *Jazz* to Andy Warhol's *Large Triple Elvis*—begins with an enlightened idea. Here's some advice on capturing that moment of inspiration and translating it into a finished serigraph.

make a thumbnail sketch

When you have a loose idea for your print in mind, draw a small, rough sketch on paper. Like writing a grocery list, the point of this thumbnail sketch is to capture and record your thoughts. Next, you can begin to develop the sketch into a fully conceptualized drawing by considering the possibilities and making decisions: Do you want to add something? Take something out? Rearrange things? Should it be vertical or horizontal? Experiment with all the possibilities you can think of at this stage, and then choose what you like best.

develop the image to scale

Now that you have a general sense of the visual elements and how they will fit together, you can begin work on a more complete drawing to scale. This is when you decide what size you want the print to be and turn the small rough drawing into a well-developed image that satisfies your artistic vision. This is an important stage in which you make many creative decisions. As you finalize your image, you may draw, erase, re-draw, cut and paste, collage, and enlarge or reduce parts.

divide the image into color groups

When you are satisfied with the drawing to scale, make some decisions about color: How many colors do you want to put in your print? Where will each color go? Remember that you build your screenprint one layer of color at a time. Do you want to have a border around your image and, if so, what size? Mark up your scale drawing with notes to yourself about image size and the placement of the colors. Also note the paper size—allow for the image, an optional border, and space for the registration holes.

mix and test colors

Mix all the inks you intend to use. The importance of mixing inks prior to printing any of them is to allow you to establish the order of printing. See how each color will look by using your squeegee to print a small test strip through the screen, as demonstrated on page 25. Do you like what you see? Do the colors relate to each other as you'd like? How do they work layered on top of each other? If you're using a transparent color, does it yield the desired level of transparency? Color tests will give you important information so you can make adjustments until you are satisfied. By doing this now, you can proceed with confidence knowing that the printed colors will meet your expectations. The next section offers some additional advice about working with color.

decide on a printing order

A good rule to follow when printing opaque colors over each other is to plan the printing sequence from light to dark. This will keep the color underneath from affecting the color on top very much, if at all.

The "light to dark" rule can sometimes help out nicely when you make a printing mistake early on. If the image calls for a darker color to cover that area of the print, you'll be covering your mistake! Also, this rule is helpful to remember as

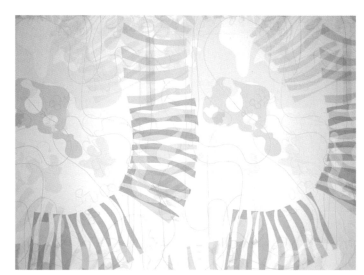

Jorge Pardo, Untitled (detail), 1999. Hand screenprint on paper-backed cotton sateen. Wallpaper width: 50 inches (127 cm). Created in collaboration with The Fabric Workshop and Museum. Photography by Aaron Igler. Courtesy of the artist and The Fabric Workshop and Museum, Philadelphia.

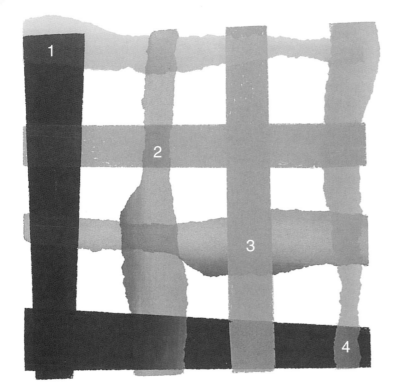

Figure 1

was created with a combination of torn paper stencils for the transparent colors and cut paper stencils for the opaque colors.)

In this example, the horizontal stripes were printed first; from bottom to top, they are opaque orange, transparent orange blend, opaque yellow, and transparent yellow.

The vertical stripes were printed next. From left to right, they are opaque orange, transparent orange blend, opaque yellow, and transparent yellow.

The differences in the results are apparent at the intersections of the stripes. At 1, opaque orange is over transparent yellow; at 2, transparent orange is over opaque yellow; at 3, opaque yellow is over transparent orange; and at 4, transparent yellow is over opaque orange. Study these differences to learn how ink colors will react in your own work.

you prepare your stencils, because it can allow for much-appreciated "cushion room" in registration when printing. Rather than precisely abutting two colors, you can prepare a stencil so the lighter color extends a bit where the darker color will cover it later, making the need for an exact registration unnecessary. This is called *trapping*.

When you're working with transparent colors, however, the light-to-dark rule isn't necessarily true because the color resulting from layering one transparent color over another will differ depending on printing order. Transparent colors are always affected by what's underneath, whether it's ink color or paper color. Experiment with the sequence of colors on a test strip so you can judge which of the variations suit you. After testing and adjusting the colors to your satisfaction, you can easily clean the small inky area of the screen with paper towels and a spray bottle of water before proceeding.

A variety of results are achieved when layering opaque and transparent colors, as shown in figure 1. Opaque colors are affected less by layering than transparent colors, but even an opaque color can still change somewhat according to its sequence in the printing order.

The screenprint in figure 1 is composed of transparent and opaque ink colors layered over each in different ways, so the effects of various color combinations are shown. (This print

print the positive or negative space

When you are finalizing your image, thinking in terms of *positive* and *negative* space can lead to new ideas and interesting results. Positive space refers to the primary image or images of a composition, while negative space refers to the background area; see the illustrations in figure 2 for examples. When preparing to print, you can consider making a stencil to print the negative space rather than the positive

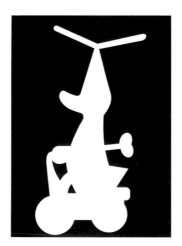 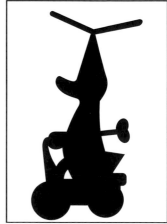

Figure 2. In the image on the left, the negative space is printed; on the right, the positive space is printed.

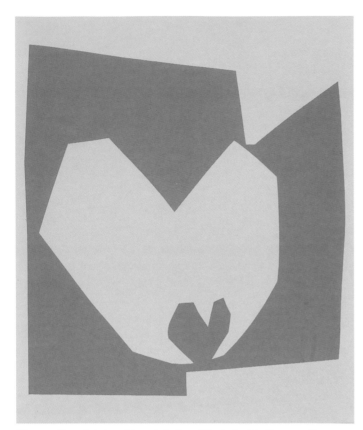

The smaller pink heart is printed positively inside the negative space of the heart outline.

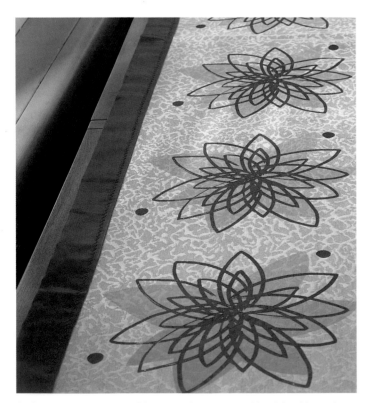

Indirect and photo-emulsion stencils were combined in this project.

image. This will suggest or define the positive image in a different way. You can also mix these two approaches, creating a print in which you have printed both the negative space and positive space at different times and in different ways, leading to some really nice overlaps and contrasts. It is easy to test these ideas by using the negative command to flip an image at the computer or the copy machine. Try other functions, too, to experiment with other compositional ideas.

exploring stencil techniques

There are many kinds of stencils and each type has its own working characteristics and strengths to consider. As you develop your idea and devise the steps for creating a print, consider which stencil technique will work best for each color layer. For example, paper stencils are great for creating big areas of a single color. Brushed stencils can lend a painterly quality to a print. Photo-emulsion stencils, because they can provide a lot of detail, are often used to great advantage as a final, defining layer.

Stencil techniques fall into three categories: indirect, direct, and photo emulsion. You can use a combination of stencils when you're making prints that have more than one color and sometimes even combine stencils within the same color layer.

indirect stencil techniques

Indirect stencils are prepared away from the screen and attached just prior to printing, such as the freezer paper stencils used in the basics section on pages 19–30.

These place mats were printed from an indirect stencil made from freezer paper.

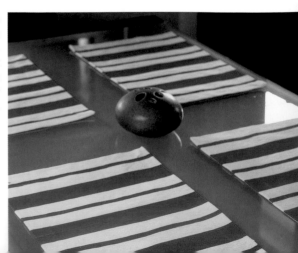

paper stencils

Paper stencils are made primarily from freezer paper, which holds up well against water-based inks. The process for working with freezer paper is found on pages 19 and 20.

As a variation, paper stencils can be torn rather than cut. A torn stencil yields softer, more irregular edges, as shown in the example on page 35. You can also create a floating stencil, in which a separate stencil sits inside another one, unattached to the outer stencil. Add a floating stencil by simply using a very small drop or two of white craft glue to adhere the floating stencil to the screen before printing.

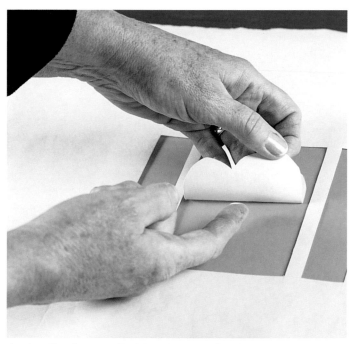

Apply a floating stencil with a tiny dab of craft glue.

Clear contact paper is an alternative to freezer paper. Draw the image on the paper backing, cut the stencil, and pull the protective layer away as you adhere the stencil to the underside of the screen. Apply extra pressure around the edges of the open areas to avoid ink bleeding through when you print.

polyester film

Polyester film also works well as an indirect stencil and it may be cleaned and reused, unlike a paper stencil, which can only be used once. (When you buy it, check to make sure it's the kind that won't stretch.) This may be an advantage if you want to work with a particular image as a theme throughout a body of work, or if you have cut a particularly intricate stencil you would like to use again in the future. Use a craft knife to cut a clean opening in the film in the same way you cut a paper stencil. There are different types of polyester film; if you are working with the frosted variety, you can draw the image directly on the frosted side of the film with a pencil. The other types of film need a special drawing product, which you can find at an art supply store. If you're not using frosted film, you can also position a drawing underneath the film to guide your cuts.

direct stencil techniques

Direct stencils are created by applying a block-out medium directly to the screen in the areas you don't want to print. These products, such as commercial screen filler and masking tape, serve as the stencil because they block the ink from penetrating the screen.

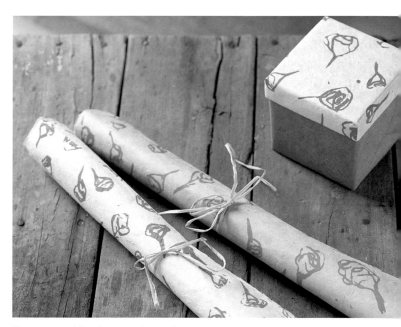

Create a positive image with a direct stencil by using screen drawing fluid and screen filler, as seen in these wrapping papers.

brushed stencils

To create a brushed stencil, apply the liquid screen filler with a brush. If you're using a drawing as your guide, slip it under the screen. Since you can see it through the screen, use a pencil to trace it directly onto the mesh. Raise the screen by placing blocks or other lifts at the corners and then apply the filler (photo 1). Have brushes in varying sizes available; use large brushes for broad coverage, small brushes for detail work. To create a straight edge, you can lay a strip of masking tape along a line—sealing it tightly with your fingertip—and then brush filler along the line (photo 2). Remove the tape when you've finished painting on the filler. When you've completed the brushed stencil, let the screen lie on the blocks to dry. Leave it in its horizontal orientation. After it's dry, check for pinholes or missed areas by holding the screen up to the light. Reapply the filler to cover all the missing areas, if necessary. Before you print, clean the pencil marks out of the screen with paper towels dampened with mineral spirits. Be sure to do this in a ventilated area, wearing protective gloves.

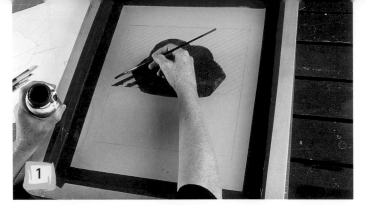

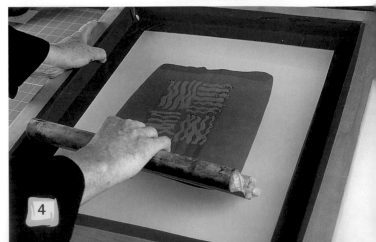

You can also draw directly onto the screen without using a guide drawing. Many serigraphers work in this spontaneous fashion, but mistakes can be difficult to correct and involve cleaning the screen to remove the filler.

hand-drawn stencils

Liquid filler also can be used in a completely different way. Draw an image on the screen with oil pastel, screen drawing fluid, or an ordinary crayon (photo 3). Use the squeegee to pull the filler across the screen over the drawing, in the same way you'd pull ink to make a print (photo 4). Make sure to do this on an elevated screen so the filler doesn't bleed through onto your work surface causing a smear on the mesh. Allow the filler to dry in place. When it's dry, clean the line drawing from the screen with mineral spirits or, if using drawing fluid, the product recommended by the manufacturer. (Remember to do this in a well-ventilated area.) The resulting open areas—where the drawing used to be—will now be ready for printing.

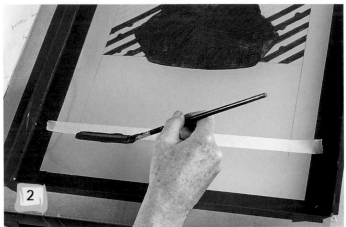

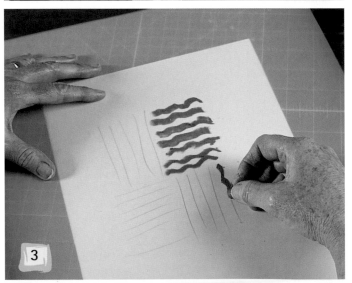

masking tape stencils

If you want to create hard-edged squares, rectangles, and other geometric shapes, use masking tape as a block-out layer. Press the tape in place on the underside of the screen. Be careful not to layer too much tape, or the thickness will inhibit a tight swipe of the squeegee, resulting in unwanted bleeding along the edges.

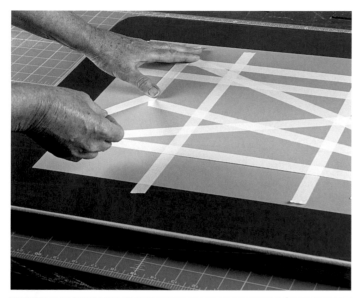

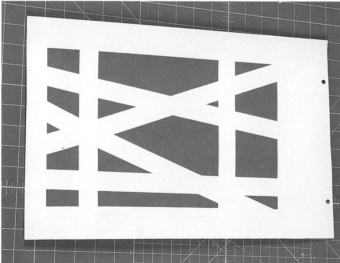

Masking tape is a very effective block-out medium.

photo-emulsion stencil techniques

A combination of direct and indirect methods, the photo-emulsion stencil is created with a light-sensitive emulsion. It is the most versatile type of stencil because you can transform almost anything into a successful stencil if you can transfer the images to transparent film or translucent vellum. You can also create the imagery directly on the film or vellum. This means you can create an image for screenprinting by drawing, painting, printing, or stamping by hand onto the transparency, or you can use a photocopy or a print from a computer. It's an excellent way to combine all your artistic pursuits with screenprinting. After each image on transparency or vellum is complete, you develop it on the screen by using light-sensitive emulsion and a light-exposure unit, which can be easily assembled for a home studio.

Create exciting imagery by using photo-emulsion stencils.

Robert Rauschenberg, *Site (Marikitch)*, 2000. Multicolored screen-print. 31½ x 23 in. (80 x 58.4 cm). Edition of 50. Published by Gemini G.E.L. ©Robert Rauschenberg and Gemini G.E.L./Licensed by VAGA, New York, NY.

The photo-emulsion method allows you to create an image with fine detail. You can make a stencil from photographic images, fine-line drawings, textures, typographical text, copyright-free images, or collaged combinations of all of these. As long as the end result is an opaque image on either transparent film or translucent vellum, it will work in this technique. You can use film or vellum interchangeably, but note: If you're working with printer or photocopy machine output on transparent film, one copy won't provide enough opacity. Print two identical copies and combine them into a double transparency using clear tape around the edges.

Here's an overview of the myriad ways you can create photo-emulsion stencils, followed by a discussion of the exposure process that produces the screen.

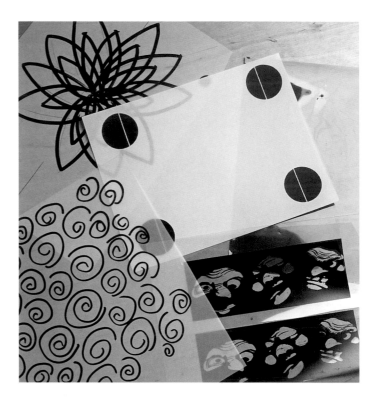

handmade photographic stencils

You can use a variety of materials to make your own artwork on the transparent film or translucent vellum that are compatible with the photo-emulsion process.

Drawing or Painting. Draw or paint directly on the transparent film or vellum with an opaque medium, such as a permanent marker, tushe stick, tushe liquid, India ink, or china marker. Use brushes with the inks or tushe liquid. (Tusche is a waxy, greasy product used primarily in lithography.)

Rubbing or Stamping. Create rubbings and textures by running a crayon back and forth across vellum placed over an object in relief. You can also stamp onto a transparency with hand-carved or purchased stamps; the transparency film allows you to easily wipe off what you've printed if you don't like it.

Masking Film. Available in red or orange, masking film is composed of a thin transparent film attached to clear plastic. To use this as a stencil, cut the softer film away, leaving

Imagery and Copyright Law

Our world is full of visual ideas and information. Magazines, newspapers, billboards, window signage, road signs—just to list a few. It's natural to develop ideas that are inspired by these visual influences and to want to incorporate imagery from these sources into your own work. This can lead to very exciting results.

Although some artists have used found imagery (also called appropriated imagery) with great success, be sure to consider copyright law when working with existing imagery. Copyright law requires that if you use copyrighted material intact or in part, you must get written permission by contacting the source, usually a publication or a person. In turn, your own work can be protected by copyright rather simply, too. Registration procedures vary from country to country, but can generally be found quickly at the public library or by an Internet search.

To avoid issues of copyright, many ready-made stencils and clip art books and images are available in art stores and craft stores. These are copyright free and available to use in any way you wish. They can be very versatile, particularly when you consider how you might use them in combination with other images or with your own original work.

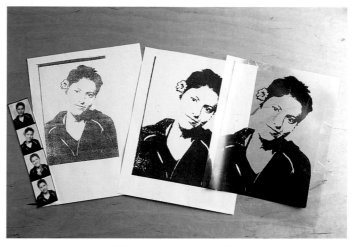

the plastic in place. (You may place a guide drawing underneath while cutting, if desired.) The film that remains will block out the light to create an excellent photo-emulsion stencil.

High-Contrast Stencils. Photographs, copyright-free imagery, or found imagery—images and text from magazines, newspapers, and other printed material—can be integrated into high-contrast stencils. If you use found imagery, however, you must be aware of the copyright status of the work you incorporate. See the discussion of this issue at the left.

You can alter imagery to suit your artistic vision by enlarging it or reducing it at a copy machine, "erasing" parts by hand with correction fluid or white paint, and adding lines or areas of black with a marking pen. You can also perform these same functions with a computer, scanning the image and using image-editing software to tweak it.

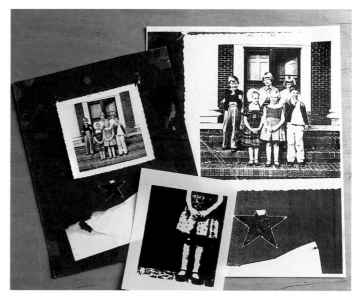

Choose an image—or even a detail—and create a high-contrast image, as shown in both of the photos on this page.

In this method of stencil making, the key to success is making sure that the image you create is one of high black-and-white contrast, without the continuous range of gray tones in between. For example, use a black marker to darken any gray areas on an initial photocopy, or adjust the settings on a copy machine to create more contrast. As you work, pay attention to how you want to alter the gray-tone areas so you end up with appropriate areas of black and white. Your original image does not have to be black and white; color imagery can be used, as long as you can create high contrast in the finished product. It's important to recognize that there's a distinct difference between a photograph, with its mid-range tones, and a high-contrast screenprinted photographic image. High-contrast images can be as striking, interesting, and detailed as a photograph, as seen in the images on the previous page.

halftone stencils

Photo-emulsion stencils can be made with continuous tones, and many are seen throughout fine art serigraphy and commercial screenprinting. However, creating a stencil that maintains the continuous tone of a photograph requires specialized chemicals and photographic equipment, which are not usually available to the home studio. On the other hand, if you have the appropriate software and expertise, it can be done at the computer. You can also take a photograph to a specialty lab to translate it into a halftone stencil.

exposing the screen

After you have created your stencil, you are ready to treat the screen with photographic emulsion. Following this step, you will expose it to light, burning the imagery onto the screen. Because the emulsion is light sensitive, you must work with it in a darkened room, using ambient light or a darkroom safelight for illumination. Set the clean and dry screen on blocks so it's slightly raised. Work first with the back of the screen facing up. Use a spatula to lay a ribbon of emulsion across one end of the screen (photo 5). Spread it across the screen evenly with the squeegee (photo 6). Check for any missed areas and patch with the emulsion. You can scoop up any excess emulsion from the edges with the spatula and return it to the container. Carefully turn the screen over and apply another layer of emulsion to the well side (photo 7). If the emulsion is too thick, it will inhibit the developing process; if the emulsion is too thin, it won't hold up well as you work with it. With a little experience, you'll develop a sense for doing this successfully.

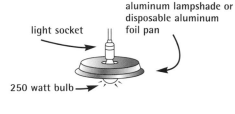

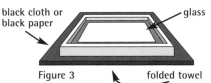

light socket — aluminum lampshade or disposable aluminum foil pan

250 watt bulb →

black cloth or black paper — glass

Figure 3 — folded towel

Leave the screen in a horizontal position on the blocks, well side up. Carefully cover the screen without touching the emulsion and leave the covering in place as the screen dries. To do this, cut a piece of cardboard the same size as the screen frame and place it on top of the screen. Cover it with a dark towel or dark piece of fabric (photo 8). It needs to sit until it is dry to the touch, anywhere from several hours to overnight.

building and using a home exposure unit

When the emulsion is dry, set up your exposure unit as in figure 3, using the materials listed in the sidebar at the right. It's remarkably easy and inexpensive to assemble your own exposure unit. Perhaps the hardest part is finding an out-of-the-way, darkened spot for the procedure. A space in a closet will do, or a room that can be kept dark for the duration of the process. The exposure unit can be set up temporarily when you need it and disassembled after use.

Fortunately, your workspace doesn't have to be totally dark, so you can use ambient light or a safelight to assemble the exposure unit, just as you did to treat the screen. Fold the bath towel in half and lay it on your tabletop surface to serve as a cushion; if one folded towel is smaller than your screen, use two unfolded bath towels. Spread the black cloth over the towel. The black cloth will absorb light, preventing it from bouncing back up and interfering with the exposure of your screen. Lay the prepared screen, well side up, on top of the black cloth. Center the vellum or transparency with the prepared imagery on top of the screen, facing up. Place the glass on top, first making sure it's clean and free of streaks or scratches (photo 9). The glass insures that the prepared imagery will make the proper contact with the screen.

The Home Exposure Unit

- 1 or 2 bath towels
- Black cloth
- Piece of clear glass just smaller than the inside dimensions of the screen
- Aluminum lampshade, 10 or 12 inch (25.4 or 30.5 cm), or disposable aluminum foil pan
- Standard light socket
- 250 watt household bulb
- Extension stand or arm from which to extend the light to the proper height and position in the center of the exposure area
- Sheet of cardboard the same size as the screen's frame
- Tabletop on which to assemble the parts
- Timer
- 4 small wooden blocks

Note: In lieu of the lampshade and light socket listed above, you can also use a commercial work light with an aluminum shade, available from any home improvement center. Be sure it will accommodate a bulb in the appropriate wattage specified.

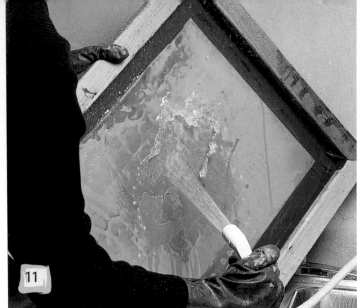

Measure the approximate outside dimensions of the image—this will determine how far away the light source should be. Refer to the chart provided by the manufacturer of the emulsion product for this information. When all the elements are in place, turn on the exposure unit light and set the timer (photo 10). Turn off the light at the end of the designated exposure time, which could be anywhere from 10 to 90 minutes. You can also use sunlight to expose the screen, though there are many variables involved in that method and the home exposure unit is much more dependable.

Since the emulsion hardens in reaction to light, the uncovered areas of the screen will harden and the areas covered by the opaque image will not. These are the areas that will wash out of the screen to create the stencil.

After the screen has been exposed, take it to your cleaning area. Follow the manufacturer's directions for washing out the screen, being sure to dispose of your wastewater properly. You can generally rinse the screen by wetting both sides and then concentrating a gentle spray of water in the image areas (photo 11). The image will wash away, leaving open mesh in these areas. You can assess your progress by holding the screen up to the light. After all the image areas have been washed away, dry your screen in a horizontal position. When it is completely dry, you're ready to print.

Screenprinting and the WPA

Culturally speaking, the Depression of the 1930s was a vibrant time. Some of the New Deal programs established by President Franklin Delano Roosevelt created an expressive outlet for artists throughout the United States. The artwork of the New Deal era was practical and socially oriented, focusing national attention on the struggles of ordinary people and the patterns of everyday life.

A former classmate of Roosevelt's, George Biddle, suggested the idea of a federally funded arts program. Inspired by Mexican muralist Diego Rivera and his socially conscious public art movement, Biddle recommended putting together a muralist team to dress up the new Justice Department building. This idea led to the creation in 1933 of the Public Works of Art Project (PWAP). The PWAP hired unemployed artists around the nation to improve public buildings in their hometowns, such as post offices, public schools, and libraries. A painting was commissioned for each member of Congress. Although cultural programs of the Work Projects Administration (WPA) eventually replaced the PWAP, all of the federally sponsored art programs had the same agenda—to document the times, to inspire the nation through art, and to provide the artists with an income.

The Federal Art Project supported painting, sculpture, writing, photography, the performing arts, and the graphic arts, including screenprinting. Because screenprinting shops could be set up and operated fairly cheaply, many now-famous artists, such as Jacob Lawrence, got their start as screenprinters through these New Deal programs. Print artists looked to the streets for inspiration, choosing as subjects both common everyday experiences as well as controversial issues.

World War II led to the downfall of Roosevelt's vision of artistic inspiration, as the Work Projects Administration formally ended in 1942. But the WPA programs had left a significant mark on cultural history. And they led to the rise of screenprinting as fine art—serigraphy—as the many artists who were exposed to the medium during this era began a lifetime of aesthetic exploration of the process.

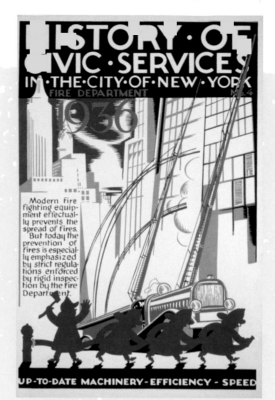

Vera Bock, *History of Civic Services in the City of New York*, 1936. Work Projects Administration Poster Collection (Library of Congress). Courtesy of Library of Congress Photoduplication Services.

Erel Osborn, *Art Classes for Children*, 1940. Work Projects Administration Poster Collection (Library of Congress). Courtesy of Library of Congress Photoduplication Services.

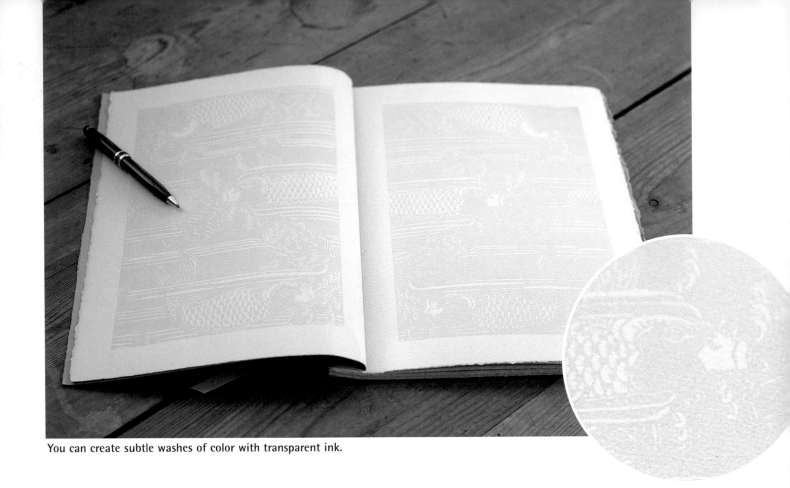

You can create subtle washes of color with transparent ink.

expanding your abilities

Now that you have an understanding of the basics of screenprinting—creating stencils and printing—there are several techniques you can employ to extend your range as a screenprinter.

When creating a transparent color, begin with transparent base. Tint with color just a little at a time, printing test swatches through the screen as you go, until you're happy with the results.

use transparent colors

Screenprinting is very conducive to bright, bold color and that is one of its strengths. Yet it would be a mistake to ignore the medium's ability to produce delicate washes of color; visual richness and depth can be so beautifully achieved by printing one transparent color over another. Because layering one transparent color over another creates yet a third shade, transparent colors are a great way to expand a print's color range. Although it takes time and testing to arrive at a transparent color that's perfect for your project, it's worth the effort. Transparent colors can add dimension and subtlety, and can provide a painterly quality like a watercolor, if desired.

create blended effects

You can create exciting effects with two or more colors printed at once. This is called a blend, a fade, a rainbow, or a split fountain. To use this technique, prepare the colors you want to blend. When your stencil is in place, attach the screen to the backboard so you'll be printing the blend of colors in the direction you'd like them to appear on the print. Then use a spatula to lay the colors you intend to blend in short strips side by side at the far end of the screen (photo 12). Blend the inks by shifting the squeegee from side to side, mixing the edges of the colors into each other with lateral movement (photo 13).

Work until there is a smooth, continuous gradation from one color to the next. Print a few tests on newsprint to make sure the blending is complete; the newsprint does not have to be registered. Be sure not to flip the squeegee or move it out of position as you print (photos 14 and 15). If necessary, you can add more ink to each side and blend it as before.

print two
colors simultaneously

This is similar to the blending process, but you keep the colors distinct from each other (photo 16). You can only incorporate this method when you have two open stencil areas that are far enough apart to keep the inks separate as you print. Use separate squeegees for each color (photos 17 and 18). If you're printing a small area, the flat edge of a piece of mat board can also be used instead of a squeegee.

use partial block outs

Occasionally you may create a stencil that contains elements you'd like to use for an entirely new project. You can block out areas of your stencil temporarily by taping a layer of paper under the area you don't want to print. This extends the versatility of your work, as the reduced image might be a stand-alone print itself, or the beginning of an entirely new idea.

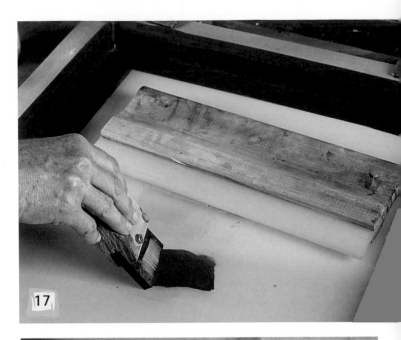

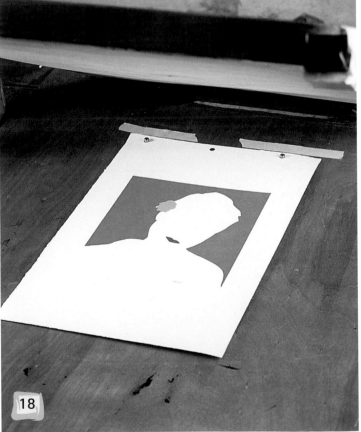

repeat-printing

If you are *repeat-printing* a design—using the same screen to print a continuous design along a length of fabric or paper—you'll want to have room to spread the length of fabric or paper out on both sides of the screen. As you print, you will move it incrementally in the same direction, as shown in figure 4. Move the fabric or paper either left to right or right to left, whichever is most comfortable for you. If the freshly printed image will still lie under the screen when you reposition the fabric or paper to print again, cover the fresh ink with clean newsprint. This will prevent a ghost image from transferring to the screen and then back to the fabric or paper.

Look at Andy Warhol's *Large Triple Elvis* on page 51 to see how effective repeated imagery can be. Projects featuring repeat-printing appear on pages 60 and 104.

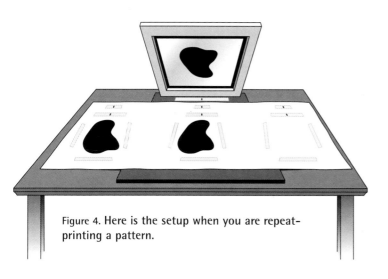

Figure 4. Here is the setup when you are repeat-printing a pattern.

19

make a reduction print

The *reduction print* is an interesting version of the brushed stencil. In a reduction print, screen filler is added in stages until the print is complete. In this manner of working, the open area of the screen is "reduced" with each subsequent application of filler. Prepare for a reduction print by creating a full-scale guide drawing of the image with all of the color areas marked. Include the paper as the first "color," if you like. Determine the color sequence for printing by following the "light to dark" rule, discussed on page 34, since each consecutive color will cover a portion of the previous one.

Use your guide to draw each stage onto the screen, beginning with the outer parameters of the print, creating a window the size of your completed image. You can also block out any areas you want to keep the same color as your paper. Your guide drawing will serve as an excellent registration guide sheet as well by attaching it to one of the papers on which you'll print. You can pencil in the exact border on this registration guide sheet, too (photo 19). The first or lightest color will cover the entire open area, except for areas you've blocked out if you want to integrate the paper as a color (photo 20). After printing the first color, clean only the ink from the screen, leaving the filler. Next, apply filler to the screen on the areas you wish to keep as the first color. Print the next color and clean the screen (photo 21). Block out with filler all

20

21

areas you wish to keep the color you just printed. Repeat this sequence for each color, watching your open area become smaller as you go, until the print is completed (photos 22, 23, and 24).

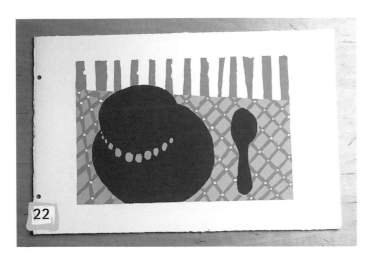

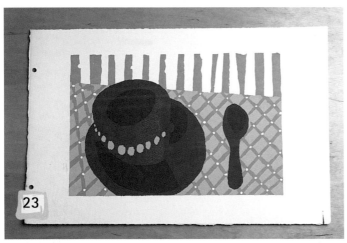

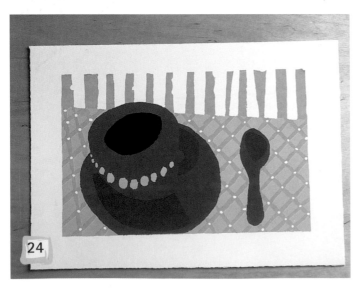

Amy Uyeki, *Bus Stop, Pietrasanta*, 1978. Silkscreen with crayon block out. 8 x 8 ³/₄ in. (20.3 x 22.2 cm).

create a monoprint

A *monoprint* is a lot of fun. This form of direct stencil produces one print, as the name implies, but can also produce a series of unique prints. Draw heavily on a clean screen with a watercolor crayon. Set up for printing. Use a squeegee to back flood the screen with clear or slightly tinted transparent base, letting it sit for about 30 seconds to soften the crayon. Print and then back flood.

In this process, the crayon is transferred to the paper. So, if you print a series, each new print will receive less crayon until it is gone. Because the image grows fainter each time, these prints are often referred to as ghost images. You can redraw the crayon lines as you go, and you can embellish the image between pulls, too, for an entirely different looking monoprint each time.

Andy Warhol, King of Pop Art

In the 1960s, screenprinting was thrust into the mainstream by American artist Andy Warhol (1928–87). As one of the founders of the Pop Art movement, Warhol sought to erase the distinctions between fine art and popular culture by using commercial production methods such as screenprinting. His art focused on icons of everyday life, from cans of soup to celebrities.

While his career began as a commercial illustrator for magazines, Warhol's creative vision was far more grand. The ambitious artist began to exhibit paintings in the 1950s and later produced serial pieces, like his seminal work *Campbell's Soup Cans*, which was exhibited for the first time in Los Angeles in 1962. He became enamored with screenprinting at this time, as the process complemented his artistic philosophy and was perfect for reproducing multiples and repeated imagery. The medium was a way to create fine art with mass production techniques, central to his concept of Pop Art as a reflection of modern society and popular culture. The 1964 debut of his *Brillo* boxes, a series of mass-produced plywood sculptures with identically printed labels, caused a sensation in the art world, unlike the Los Angeles exhibit which had met with critical scorn.

His early screenprinting techniques involved vivid base colors and various experiments with registration; he would later purposely print works off-register, creating subtle yet important differences in his serial pieces. During his experimentation with serigraphy, Warhol completed many portraits of celebrities and friends. After actress Marilyn Monroe died during this period, she became the first iconic subject for his innovations with photographic stencils, which offered countless creative possibilities for portraiture. Initially, he worked from existing photographs, but he later began to take his own portraits with an instant camera, devising a system to enlarge and transfer the images to the screen for printing. His subjects included Elvis Presley, Jacqueline Kennedy, Mick Jagger, Muhammad Ali, even Mao Zedong.

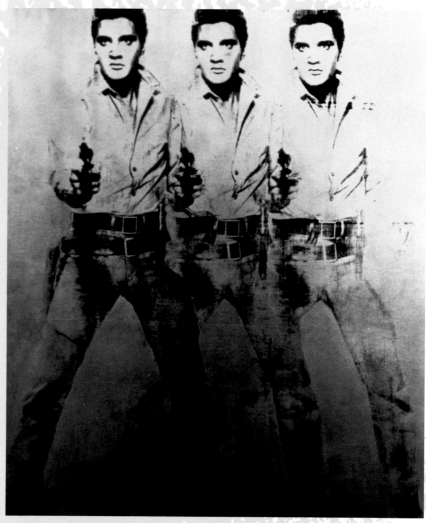

Andy Warhol, *Large Triple Elvis*, 1963. Synthetic polymer paint and silkscreen ink on canvas. 82 x 82 in. (208.3 x 208.3 cm). Photography by The Andy Warhol Foundation, Inc./Art Resource, NY. ©2004 The Andy Warhol Foundation for the Visual Arts/Artists Rights Society (ARS), New York.

Andy Warhol's subject matter of widely recognizable people and events garnered both intense acclaim and scrutiny. The international attention given to the artist, his art, and his techniques definitively transformed popular notions of screenprinting from a humble commercial process to fine art.

materials and tools list

Here are the basic materials and tools that you will need to begin screenprinting. In the project instructions in the Applying Your Skills section, you will find these items referred to collectively as *screenprinting setup and supplies.*

materials

- Tracing paper
- Freezer paper
- Cellophane tape
- Sealing tape
- Masking tape
- Screenprinting ink for paper and textiles
- Retarder (if required for the ink you select)
- Transparent base
- Printing paper
- Fabric
- Foam-core board
- Absorbent paper towels
- Dish soap
- Photographic emulsion
- Emulsion remover
- Screen drawing fluid
- Screen filler
- Liquid tusche and/or other opaque drawing mediums
- Oil pastel or ordinary crayon
- Brushes, various sizes
- Temporary spray adhesive
- Opaque black markers, various sizes
- Translucent vellum
- Transparency film
- Polyester film, clear and frosted
- Masking film
- Pencil
- Carbon paper
- Craft glue
- Newsprint and/or recycled newspaper

tools

- Scissors
- Craft knife
- Screen
- Backboard
- Hinge clamps
- Squeegee
- Plastic spatulas
- Straightedge
- Adjustable two- or three-hole punch
- Register pins
- Plastic containers with lids
- Gloves
- Scrub brushes
- Sink, bathtub, or plastic tub with garden hose
- Spray nozzle attachment
- Pressure washer (optional)

For the items you need to build a home exposure unit, see page 43.

applying your skills

Screenprinting is a versatile medium. You can screenprint on almost any surface, including those that have curves and are three dimensional. The projects you will find in this section allow you to explore the many facets of serigraphy.

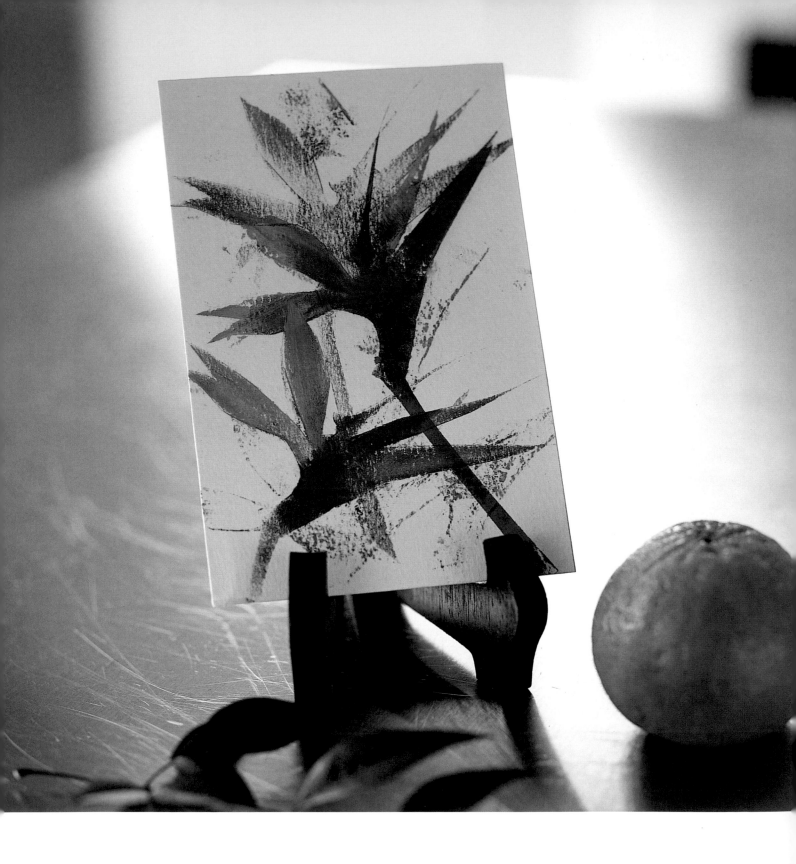

stenciled post cards

Experience the essence of screenprinting as you make these hand-stenciled postcards. Repeat the process to add as many images as desired.

Materials and Tools

Screenprinting setup and supplies
Heavyweight paper or card stock
Drawing paper
Stencil brush

SKILL LEVEL: **Beginner**
STENCIL METHOD: **Hand stencil**
INK TYPE: **Acrylic paint; colors as desired**

Printing Instructions

1 Cut the paper into cards that are each 4 x 6 inches (10.2 x 15.2 cm).

2 On paper, draw a simple outline of a flower, such as the bird of paradise shown here. Place a sheet of transparency film over your drawing and cut the flower shape out of the transparency by tracing the pencil lines with a craft knife.

3 Spray the back of the cut transparency film with temporary spray adhesive and press it into position over one of the postcards. Use a stiff stenciling brush to paint the colors through the stencil. Let each card dry thoroughly.

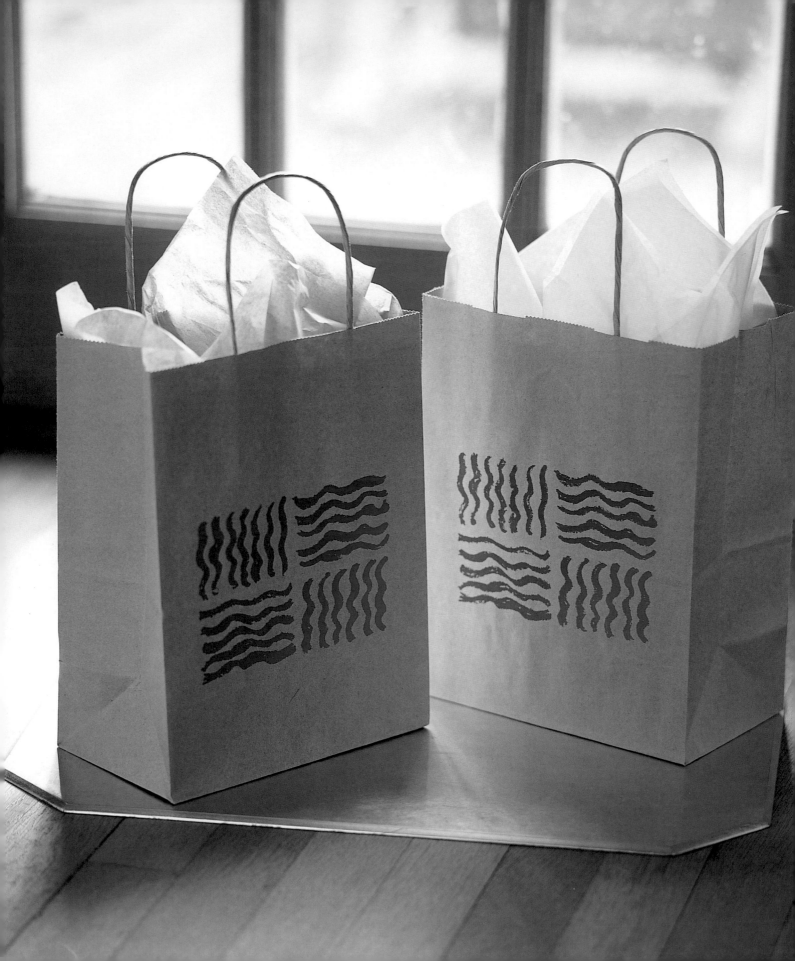

decorated brown bags

Turn a simple brown bag into an artful presentation with a fetching pattern created from blended ink. The same stencil can be used on an assortment of bags.

Materials and Tools

Screenprinting setup and supplies
Sturdy brown bags, with or without handles
Manila folder
Newsprint (optional)
4 small wooden blocks

SKILL LEVEL: **Beginner**
STENCIL METHOD: **Direct (oil pastel or ordinary crayon and screen filler)**
INK TYPE: **Water based; 2 shades of the same color**
REGISTRATION METHOD: **Masking tape**

Printing Instructions

1 Look to see if your bag has a seam. If it does, the seam should be on the back. If the bottom of the bag happens to be folded up against the front, reverse the fold on each of the bags so the bottom folds up against the seamed, or back, side of the bag.

2 Using one of the brown bags as a guide for the size of your image, draw a design on paper that fits within the area on the bags you'd like to embellish. Use the drawing as a guide, centered under the screen, and transfer the image to the screen with the oil pastel or crayon.

3 Measure the dimensions of the front side of the bag and cut a piece of the manila folder just narrower than the width of the bag, but an inch (2.5 cm) or more longer than the length of the bag. It should be easy to slip in and out of each bag as you print, for the manila piece will provide a smooth surface for printing each bag.

4 Elevate the screen by placing a block under each of the four corners. Finish the screen by applying filler, letting it dry, and then removing the drawing medium, as described on page 38.

5 On the screen, prepare a blend of the two colors as described on page 46. (You may want to test the blend on newsprint before you begin the registration process.) After you make the first pull on the polyester film, use a bag to register the image, applying masking tape to the backboard along three sides. Each time you print, you'll insert the manila piece into a new bag, removing it after printing and laying the bag aside to dry.

Variation: If you want to print this design on more than one size bag, you can make registration marks for each size from masking tape, placed on the backboard at the same time. Be sure to label the tape so you know where to place each size of bag. In this manner, you can use the same screen to print on two different objects. See page 22 for more photos of this technique.

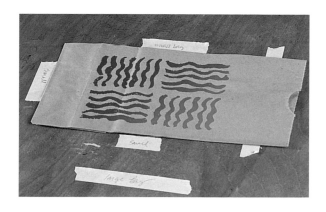

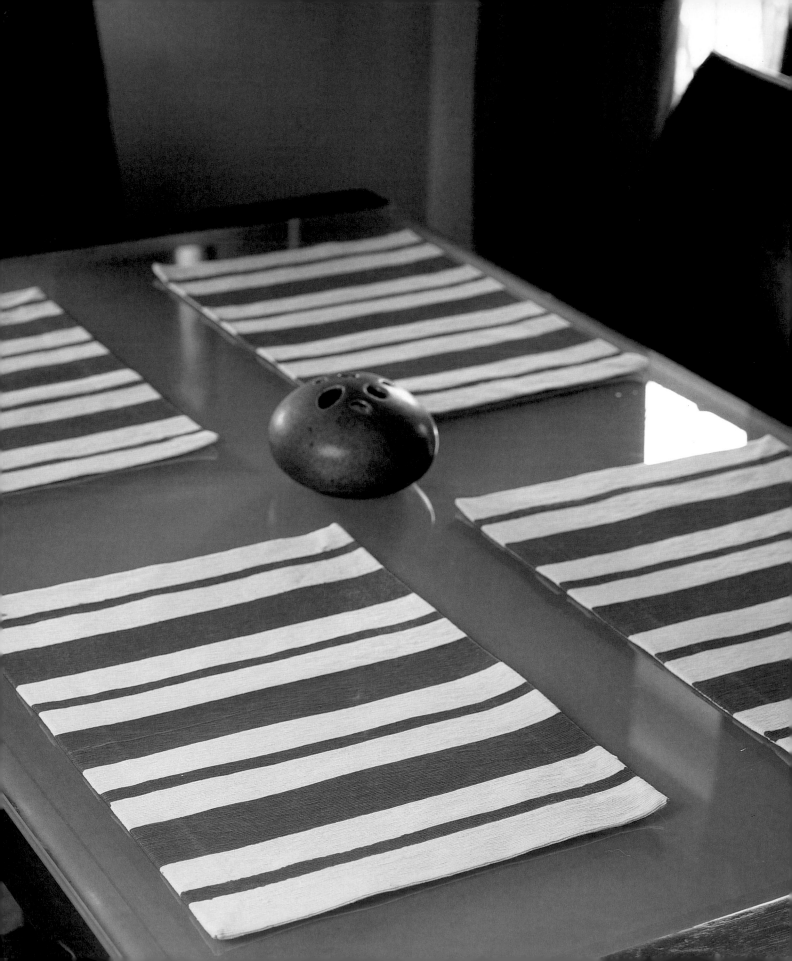

perfect place mats

These place mats—certainly not lacking in panache—are easy to make in any color scheme.

Materials and Tools

Screenprinting setup and supplies
Purchased place mats in a light, solid color
Mat board
Iron and ironing board

SKILL LEVEL: **Beginner**
STENCIL TYPE: **Indirect (paper)**
INK TYPE: **Water-based textile ink; 1 color**
REGISTRATION METHOD: **Masking tape**

Printing Instructions

1 Cut a variety of stripes from freezer paper to create a paper stencil.

2 Make a backing structure for each place mat from the mat board; the backing structures should be the same size as the place mats. Use temporary adhesive spray to adhere each place mat to its backing structure. If the mats aren't exactly the same size, cut the backing structure pieces to the largest mat and center the smaller ones on their backing structures. This will insure that the design is centered on each mat.

3 To set registration, use one place mat as a guide under the polyester film and place masking tape strips on the backboard at the corners and along the top of the mat. Remove the film after you've set the registration.

4 Print the mats and let them dry on their backing structures.

5 Heat set each place mat with the iron, following the ink manufacturer's instructions.

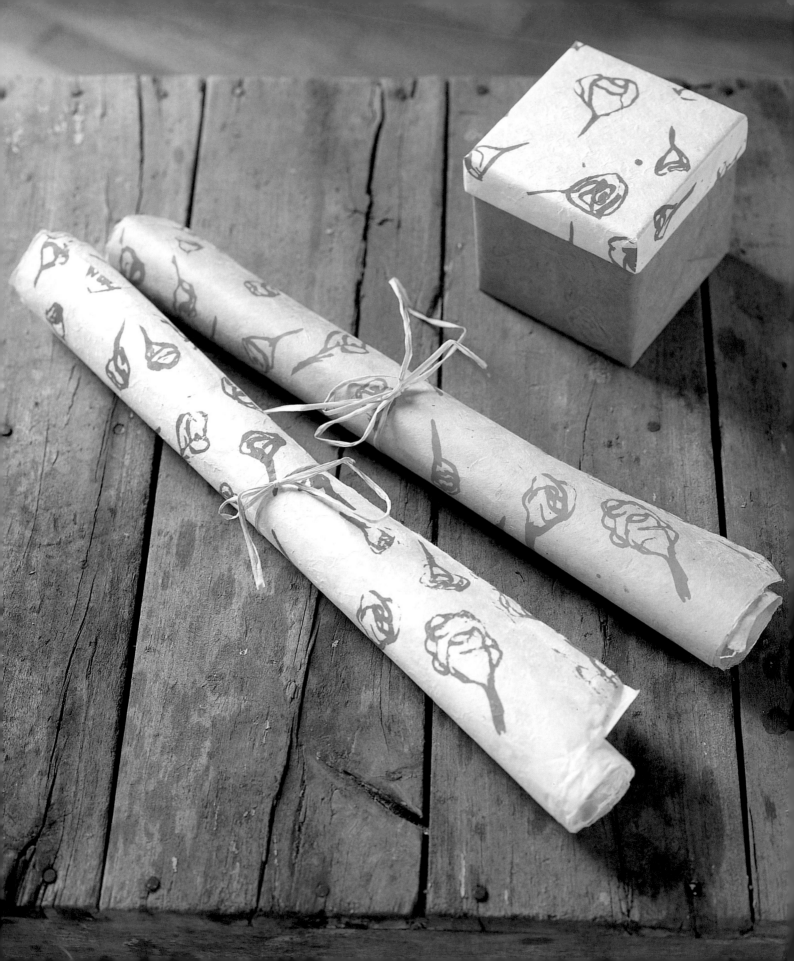

roses wrapping paper

Make a gift truly special by using wrapping paper of your own design. Vary the size of the graphic components in your pattern.

Materials and Tools

Screenprinting setup and supplies
Purchased handmade paper
Sheet of drawing paper the same size as the screen
4 small wooden blocks
Several sheets of newsprint

SKILL LEVEL: **Beginner**
STENCIL TYPE: **Direct (screen drawing fluid and screen filler)**
INK TYPE: **Water based; 1 color**
REGISTRATION METHOD: **Masking tape**

Tip: A heavier paper with a smooth surface is the best choice for this project. Be sure to choose sheets that have been kept flat, not rolled.

Printing Instructions

1 If necessary, tear the paper so it's no longer than the screen. It's okay if the paper is be wider than the screen, because the image will be repeat-printed, as described on page 49. You'll move the paper during the printing process to do this.

2 With a pencil, draw an overall design that fills the drawing paper. A loose pattern that doesn't require exact registration is best for this project. Transfer the image to the screen with a pencil. Place the screen on the blocks, one under each corner, and paint over the pencil marks with screen drawing fluid and a brush. Finish the screen by applying screen filler, letting it dry, and then removing the screen drawing fluid, as described on page 38.

3 Measure the size of the screen image and mark its outside dimensions on the backboard with a pencil or tape. Measure and mark the paper from the corner with pencil marks that indicate the exact width of the image. Set the registration by printing on polyester film first and then positioning the paper so the image will begin to print at the edge of the paper. Use the guides to move the paper as you print, matching the marks on the paper with the guides on the backboard; after you've completed the first swipe on the paper, move it over to match the next mark with the guide on the backboard.

4 Gently lay a piece of newsprint on top of the freshly printed portion of the paper that is situated under the frame of the screen, so the fresh ink won't transfer back to the screen during the next run. Then print again. You will print the pattern in two or more pulls over the length of the paper.

child art greeting card

A favorite drawing is transformed into a memorable set of greeting cards. Choose a drawing with plenty of contrast for the best results.

Materials and Tools

Screenprinting setup and supplies
Child's drawing, in dark colors on
 white paper
Cards and envelopes

SKILL LEVEL: **Beginner**
STENCIL TYPE: **Photo emulsion
(image on vellum or double
transparency)**
INK TYPE: **Water based; 1 color**
REGISTRATION METHOD: **Masking tape**

Printing Instructions

1 Select the area of the drawing you wish to use for the image; it could be part or all of the original drawing. Resize at the computer or copy machine, if needed, to fit the dimensions of the card and create a high-contrast copy on one sheet of vellum or two sheets of transparency film. Use the techniques suggested on pages 41 and 42 to create a high contrast image you like. You can also use a scanner and computer to reproduce the image on the vellum or transparency film; remember that you need a double transparency of printed or copied output on film.

2 Prepare the photo-emulsion stencil. Register and print the cards. Let them dry.

napkins with folk art design

Evoke a nostalgic mood with these simple yet dramatic table linens. Create the image from construction paper.

Materials and Tools
Screenprinting setup and supplies
White napkins
Black construction paper
Drawing paper
Glue
Mat board
Iron and ironing board

SKILL LEVEL: **Beginner**
STENCIL TYPE: **Photo emulsion (image on vellum or double transparency)**
INK TYPE: **Water-based textile ink; 1 color**
REGISTRATION METHOD: **Masking tape**

Printing Instructions

1 Cut a piece of white paper that's a quarter the size of the full napkins.

2 Keeping in mind the size of the white paper, draw a variety of simple shapes in various sizes on one side of a piece of the black construction paper. Fold the paper in half and cut the shapes through both thicknesses so you have two identical pieces for each shape. Create two figures from another piece of black construction paper.

3 Arrange the figures and the shapes into a pleasing design on the white paper and glue the pieces in place. At the computer or copy center, make one copy on vellum or two copies on transparency film. (Remember that you need two copies on transparency film so the image is opaque enough to use.) Expose a photo-emulsion stencil on the screen from the image you created in this step.

4 Make a backing structure for each napkin from the mat board; the backing structures should be a quarter the size of the napkins. Use temporary spray adhesive to adhere the backing structure to the area of the napkins (a quarter of the total surface) where you'll print the image. For registration, lay masking tape strips along the two sides and corner of the portion of the napkin to be printed. Use temporary spray adhesive to hold the backing structure in place on the backboard while printing.

5 Register and print each napkin and let them dry on the backing structures. Heat set the napkins with an iron according to the ink manufacturer's instructions.

yard signs and arrows

Direct guests to your progressive dinner party, garden tour, or studio stroll with these fluorescent signs. It will be hard to ignore them with their bold juxtaposition of color.

Materials and Tools

Screenprinting setup and supplies
Neon poster board
Neon card stock
Stakes for the signs
Staple gun and/or masking tape

SKILL LEVEL: **Beginner**
STENCIL TYPE: **Indirect (paper)**
INK TYPE: **Water based; 1 bright color**
REGISTRATION METHOD: **Register pins**

Printing Instructions

1 Prepare a guide drawing for the house shape that will fit inside your screen and then prepare a paper stencil. Since you are working with large sheets of poster board, make sure there is room on the backboard for the register pins where you'll likely want to place them. (If there isn't room for the register pins, use masking tape for registration.) Punch holes in the poster board for registration, and use polyester film to register. Print each poster and allow each to dry. Trim away the edge that has the registration holes.

2 Repeat step 1 to create the arrows, preparing as many as needed to direct your guests.

Finishing Instructions

Staple or tape the house sign to the stake, adding a crossbar, if desired. The arrow signs can also be put on stakes, stapled to wooden gates or fences, or taped to walls and surfaces to point the way to your home.

Tip: Use a different color poster board to identify each home or studio on a tour.

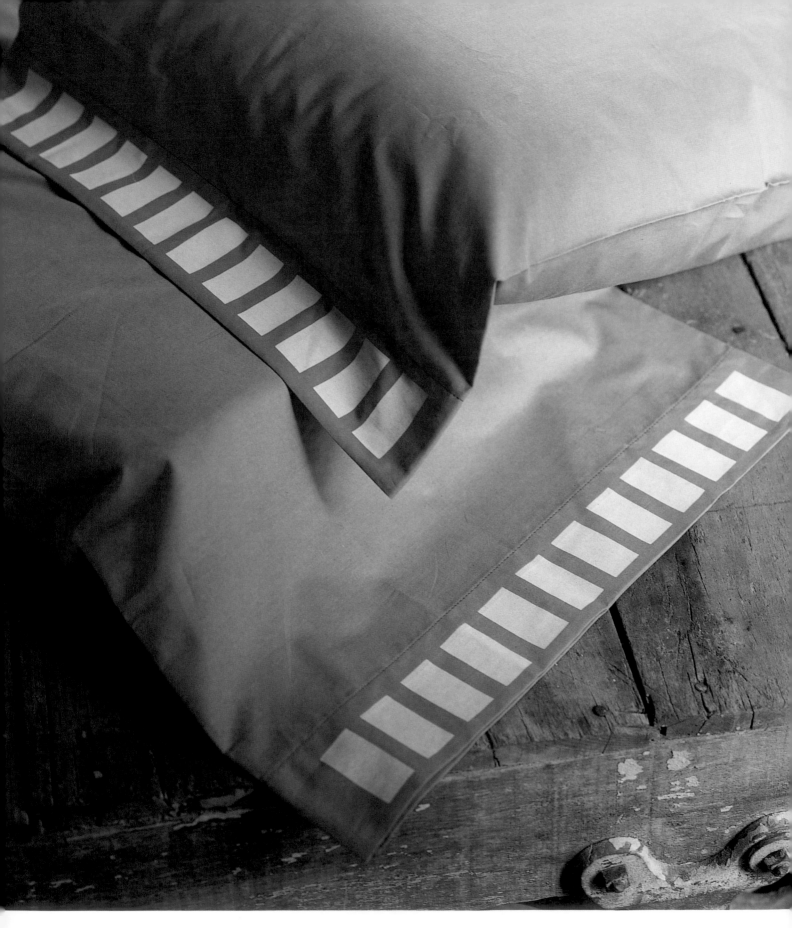

pillowcases with accents

Add contemporary flair to your linens with this striking geometric design. An inspired color choice completes the look.

Materials and Tools
Screenprinting setup and supplies
Pillowcases
Mat board
Iron and ironing board

SKILL LEVEL: **Beginner**
STENCIL TYPE: **Indirect (paper)**
INK TYPE: **Water-based textile ink; 1 color**
REGISTRATION METHOD: **Masking tape**

Printing Instructions

1 Cut a long, rectangular backing structure for each pillowcase from the mat board. The backing structure should fit snugly inside the case from side to side. It should be wide enough to extend to the edge of the pillowcase's inner edge seam and long enough to extend a couple of inches (5 cm) outside the pillowcase. Spray each side of the backing structure with temporary adhesive spray and slip the mat board piece into the case, smoothing the wrinkles and attaching the fabric as you go.

2 For registration, slip the pillowcase and its backing structure under the polyester film into the correct alignment under the printed design on the film. Lay masking tape strips at the corners of the mat board. Remove the polyester film. Use temporary adhesive spray on the backboard to help hold each backing structure in place. Print one side of all the cases first, as shown, leaving them on their backing structures. They'll dry quickly, and then you can print the other side. Leave the cases on the backing structures until both sides are dry.

3 Heat set the textile ink with an iron, following the ink manufacturer's instructions.

brightly striped windmills

There's no more perfect party favor for a child than these stylish windmills, but they would make lovely garden art, too.

Materials and Tools
Screenprinting setup and supplies
Card stock, 8¹/₂ x 11 inches
 (21.6 x 27.9 cm), multiple colors
Dowels, ¹/₄ to ¹/₂ inch (6 mm to
 1.3 cm), cut to 15-inch (38.1 cm)
 lengths
Drill, with bit sized for the dowels
Sandpaper
Corsage pins, 2 inches (5 cm) long
Cork stoppers, cut to ¹/₂-inch
 (1.3 cm) widths and sanded smooth

SKILL LEVEL: **Beginner**
STENCIL TYPE: **Indirect (paper)**
INK TYPE: **Water based; 1 bright color**
REGISTRATION METHOD: **Register pins**

Printing Instructions

1 Punch registration holes in the sheets of card stock, making sure the holes are an equal distance from each side (photo 1). This will allow you to print both sides and have the stripes match without having to set a new registration for the second side.

2 Prepare the paper stencil by using a craft knife to cut ¹/₂-inch (1.3 cm) stripes across an area on the freezer paper that is 8 by 9 inches (21.6 x 22.9 cm).

3 When positioning the card stock under the polyester film for registration, make sure that the stripes will be printing an equal distance from each side of the sheet, per step 1.

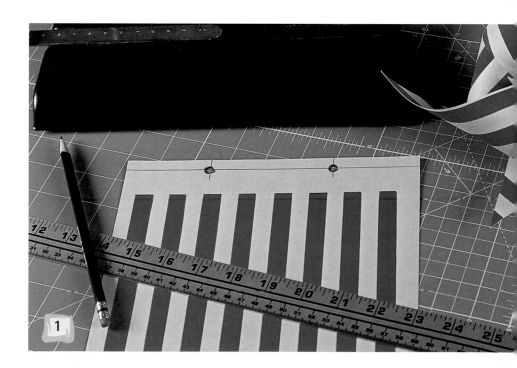

4 Print one side of all the sheets and let each sheet dry. Then print the other side without moving the register pins. This insures that the stripes will print exactly on top of each other on each side of the sheet. When the windmill is cut to size, the stripes will match at the edges.

Finishing Instructions

1 Drill a hole through each of the dowels, $1\frac{1}{4}$ inches (3.2 cm) from one end. Sand all the ends smooth.

2 Cut each printed sheet into 6-inch (15.2 cm) squares. Use a straightedge to draw $2\frac{3}{4}$-inch (7 cm) lines diagonally from each corner inward. Use a craft knife to make cuts along the lines (photo 2).

3 With a corsage pin, punch a hole on one side of the diagonal cut you made at each corner. Punch a hole in the center of the square. Bend each of the points with a hole into the center, lapping them over each other (photo 3). Stick a corsage pin through the points and through the middle of the windmill. Slip the end of the pin through the hole in the dowel and into a cork stopper (photo 4). Repeat this step for each windmill.

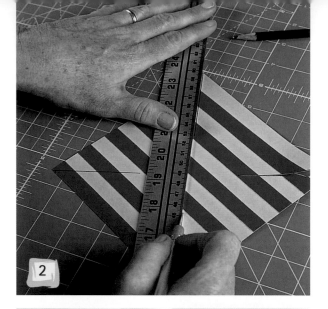

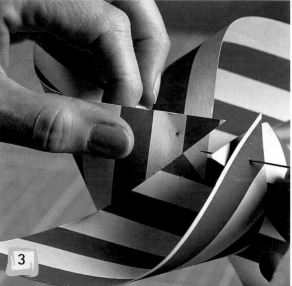

Screenprinting and Popular Culture

In the early 1960s, prominent artists in the Op Art and Pop Art movements helped propel screenprinting into the vanguard of popular culture as their influence spread beyond the fine art world. Some of its major proponents—Andy Warhol, Roy Lichtenstein, and James Rosenquist—all had experience with commercial art that influenced the content of their creations.

A new group of artists began to create works based on their own very different influences when screenprinted psychedelic rock posters exploded onto the cultural scene toward the end of the decade. These bold posters often featured a blend of unusual lettering and swirling illustrations in electrified colors. The posters reflected the climate of the times as they attempted to capture visually the effects of mind-altering substances that influenced many contemporary visual and performing artists. Art and music became intertwined, for the concerts were happenings—the audience members were considered active participants in the events.

The artists created posters for these musical events held at venues like the Fillmore Auditorium and the Avalon Ballroom in San Francisco. Wes Wilson, Stanley Mouse, Bob Masse, Rick Griffin, Lee Conklin, and Victor Moscoso were some of the poster artists whose work sought to capture the adventurous spirit of the 1960s. As daring experiments in form, color, and lettering, their posters were some of the first commercial art to make the message subservient to the artist's expression. Elements contained in these posters were embraced by the mainstream as psychedelic colors and images were translated into the fashion and design industries.

Today, exhibits in museums devoted to contemporary music, such as the Rock and Roll Hall of Fame in Cleveland, Ohio, have lent cachet to the concert poster as legitimate art. This recognition has fueled localized movements in screenprinted concert advertisements, as visual art continues to support and promote music in all genres.

Bob Masse, *Trips Festival, with Jefferson Airplane*, Richmond Arena, B.C., Canada, 1967. 14 x 20^1/$_2$ in. (35.6 x 52.1 cm). Courtesy of Bob Masse Studios.

Casey Burns, *Le Tigre*, 2002. Three-color screenprint. 14 x 19^1/$_2$ in. (35.6 x 49.5 cm). Edition of 62. ©Casey Burns. Courtesy of the artist.

takeout cartons

Add a graphic design to these versatile boxes; just disassemble the cartons to print them.

Materials and Tools
Screenprinting setup and supplies
Purchased cartons
Drawing paper

SKILL LEVEL: **Intermediate**
STENCIL METHOD: **Photo emulsion (hand-drawn image on frosted polyester film)**
INK TYPE: **Water based; 1 color (a second color is optional)**
REGISTRATION: **Masking tape**

Printing Instructions

1 Detach the metal handle on each carton and flatten the boxes. Use one flattened carton to create an outline on drawing paper so you can work out an overall design to the correct size. When you're satisfied with the pattern you've created, lay a piece of frosted film over the drawing and transfer it to the film using an opaque black marker. Use this frosted film to create a photo-emulsion stencil.

2 Print one color on all the boxes. If you like, print a second color using the same stencil. Gently clean the ink out of the screen so the emulsion doesn't erode. Then print the second color, positioning the flattened boxes in the opposite direction so the pattern prints differently. Let the cartons dry.

Finishing Instructions
Reassemble the cartons and re-insert the handles.

NOTE: Yes, it is safe to use these boxes for food, as the ink doesn't permeate the carton. But they are perfect for the clever presentation of a gift, too.

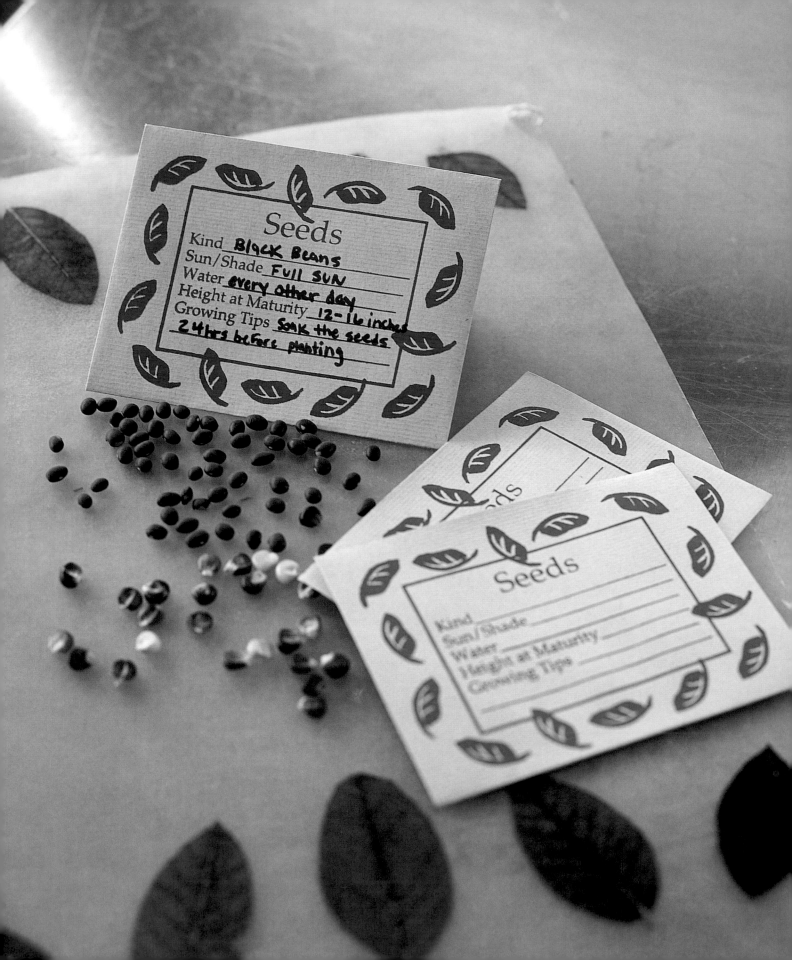

gardener's seed packets

Share the bounty of your garden in these delightful seed packets. Use hand-stamped accents to embellish the stencil.

Materials and Tools

Screenprinting setup and supplies
Envelopes
Rubber carving block and cutting tool
 (or purchased stamp)
Black relief ink
Brayer

SKILL LEVEL: **Intermediate**
STENCIL METHOD: **Photo emulsion (image on double transparency)**
INK TYPE: **Water based; 1 color**
REGISTRATION METHOD: **Masking tape**

Printing Instructions

1 Cut a small leaf stamp from the cutting block, or use a purchased stamp if you prefer. At the computer, create the text and outline for your packet and print it onto transparency film. You can also draw the outline with black marker on paper, add computer-generated text, and get a transparency made at the copy center. Remember that you need a double transparency—two copies—to create a stencil that is opaque enough to use.

2 Ink the leaf stamp, using the brayer and black relief ink. Hand stamp a pleasing motif for the border on the transparency. If you make a mistake, or you're unhappy with your design, you can wipe off the ink with a damp paper towel or sponge and try again. (You can remove the ink even if it is already dry.)

3 Prepare a photo-emulsion stencil from the double transparency and then print the seed packets. Allow each packet to dry.

aprons for a group

Take advantage of screenprinting's ability to create multiples when you produce this apron, a great gift for a gourmet cooking club or a crafts group.

Materials and Tools
Screenprinting setup and supplies
Mat board
Aprons
Iron and ironing board

SKILL LEVEL: **Intermediate**
STENCIL TYPE: **Photo emulsion (image on vellum or double transparency)**
INK TYPE: **Water-based textile ink; 1 color**
REGISTRATION METHOD: **Masking tape**

Printing Instructions

1 Prepare the photo-emulsion screen, having printed your chosen imagery on one sheet of vellum or a double transparency. If you would like to work with an image that you paint or draw directly onto a transparency, remember that you can use just one sheet of transparency film as long as the image is opaque.

2 Prepare a backing structure for each apron and adhere it to the fabric with temporary spray adhesive.

3 After your first pull on the polyester film, slip the first apron and backing structure under the film and use masking tape to mark the backboard for registration on three sides. Spray temporary adhesive on the backboard to hold the fabric in place during printing.

4 Print each apron and allow each to dry. Heat set the ink with an iron as directed by the ink manufacturer.

MAI · MAY · MAYO

Monday lunes lundi	Tuesday martes mardi	Wednesday miércoles mercredi	Thursday jueves jeudi	Friday viernes vendredi	Saturday sábado samedi	Sunday domingo dimanche
2	3	4	5	6	7	8
9	10	11	12	13	14	15
16	17	18	19	20	21	22
23	24	25	26	27	28	29
30	31					

embellished calendar

Make a keepsake calendar to creatively record all the important events of the year. Decorate the calendar to express your thoughts and feelings as time goes by.

Materials and Tools
Screenprinting setup and supplies
Mat board
Archival paper
Book rings
Stamps and ink

SKILL LEVEL: **Intermediate**
STENCIL TYPE: **Photo emulsion (images on vellum and double transparency)**
INK TYPE: **Water based; 1 color**
REGISTRATION METHOD: **Register pins**

Printing Instructions

1 Draw a monthly calendar format to scale on a piece of tracing paper. Transfer it in pencil to a piece of vellum and carefully trace over the lines with a black marker. Add computer-generated text on double transparency, taping it in place with clear tape. Cut away as much of the overlap in the image areas as possible; this will help keep light refraction to a minimum during the exposure stage. You can also create the calendar entirely on the computer, if desired, printing it in sections onto one sheet of vellum or two sheets of transparency film and taping together the sections.

2 Prepare a photo-emulsion stencil using the image from step 1.

3 Using the prepared image as a guide, determine the desired size for the calendar pages, with extra paper at the top to allow for the registration holes. Cut or tear 12 sheets of archival paper to size, adding a few extras in case of printing errors.

4 Punch registration holes at the top of each page, making sure the holes are centered. Register and print the pages and let them dry.

Finishing Instructions

1 Cut the mat board slightly larger than the calendar pages. Punch holes in the board so the pages will be centered on the mat board when the holes in the mat board are lined up with the holes on the calendar pages.

2 Assemble the calendar by placing the book rings through the registration holes at the top of the pages, with the mat board on the bottom. Use stamps to add the days of the month, and embellish the calendar as desired. As the year progresses, record events, memories, and important milestones.

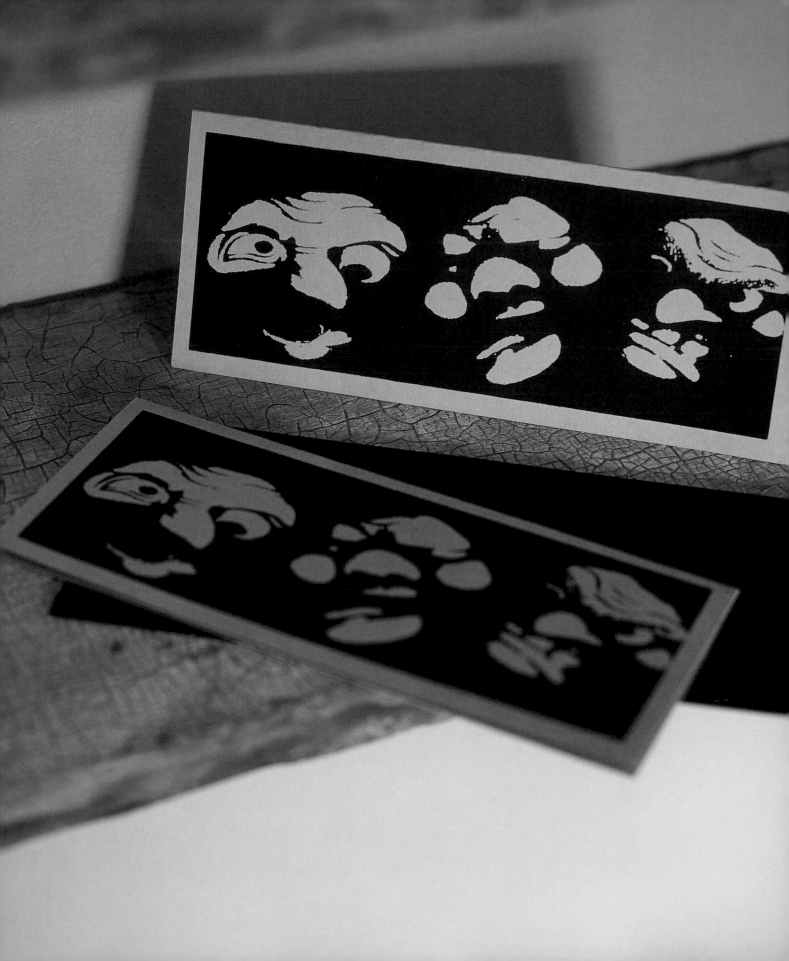

found object invitations

Here are two variations on the idea of using found objects to create a photo-emulsion stencil. As you can see, this method can produce remarkably different results.

Materials and Tools

Screenprinting setup and supplies
Orange card stock
Black envelopes
3 rubber hand puppets, or comparable soft items that can be placed in a copier or scanner
Bone folder

SKILL LEVEL: **Intermediate**
STENCIL TYPE: **Photo emulsion (image on vellum or double transparency)**
INK TYPE: **Water based; 1 color**
REGISTRATION METHOD: **Register pins**

Printing Instructions

1 At a scanner or copy machine, arrange the found objects face down on the glass. Press them into the glass gently; if you use puppets, press them enough that their faces distort to make scary images. Make a scan or copy. Rearrange and scan or copy again until you get a composition you like. The image should fit within a $3^1/_2$ x $8^1/_2$-inch (8.9 x 21.6 cm) area, allowing for a border if desired.

2 If you're working at a computer, use an image-editing program to tweak the image until it has plenty of contrast. Then print the image onto two sheets of transparency film or one sheet of vellum. If you're working at a copy machine, use black marker, correction fluid, etc., and alter the image so it becomes black on white, using the suggestions on pages 41 and 42. Have one copy made on vellum or two on transparency film; tape the latter together along the edges to make a double transparency.

3 Use your completed image to make a photo-emulsion screen.

4 Punch registration holes in the far end of the paper. (After printing, you'll cut off this end at the 7-inch [17.8 cm] line on each of the cards, as indicated in figure 1.)

5 Measure and mark one sheet of the card stock, drawing a dotted line across at $3^1/_2$ inches (8.9 cm) and a solid line at 7 inches (17.8 cm) as shown in figure 1. Use this sheet as a registration guide under the polyester film. Be sure to position the guide sheet so the image will print facing the outer edge of the card

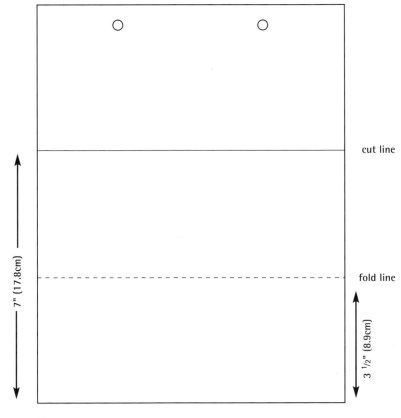

Figure 1

rather than the fold line. After you've set and taped the register pins, remove the polyester film and guide sheet.

6 Print each card and let dry. Score and fold each card at the 3½-inch (8.9 cm) line, using a bone folder.

Variation: Use the same technique to create a decidedly more elegant invitation. The stencil for the cards shown above was created from actual fern fronds that were placed on the copy machine. Add a border and print on fine paper to complete this sophisticated variation.

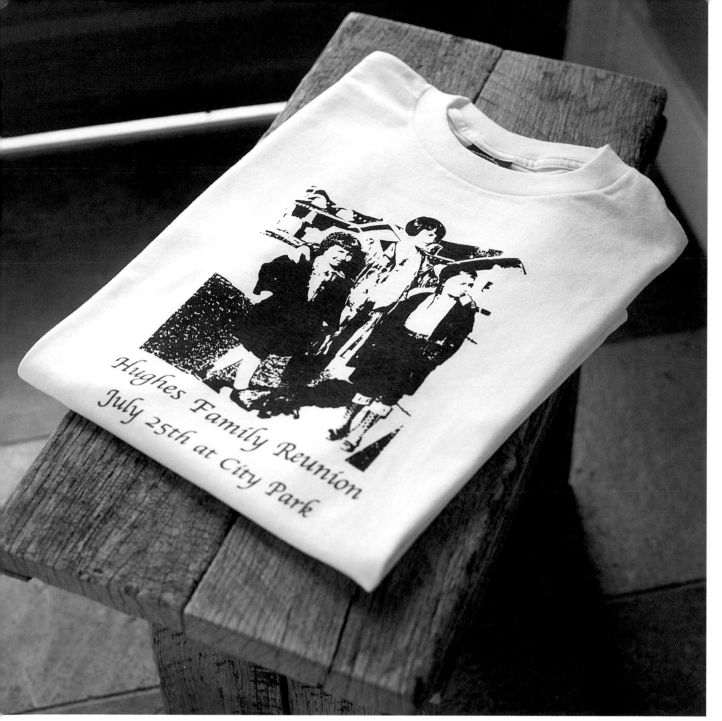

The image on the shirt reads: *Hughes Family Reunion July 25th at City Park*

family reunion t-shirts

Take a charming family photo and create a high-contrast image to use in making dozens of shirts for a special gathering of loved ones.

Materials and Tools

Screenprinting setup and supplies
Family photo
Correction fluid or white paint
White T-shirts
Mat board
Iron and ironing board

SKILL LEVEL: **Intermediate**
STENCIL METHOD: **Photo emulsion (image on vellum or double transparency)**
INK TYPE: **Water-based textile ink; 2 colors**
REGISTRATION METHOD: **Masking tape**

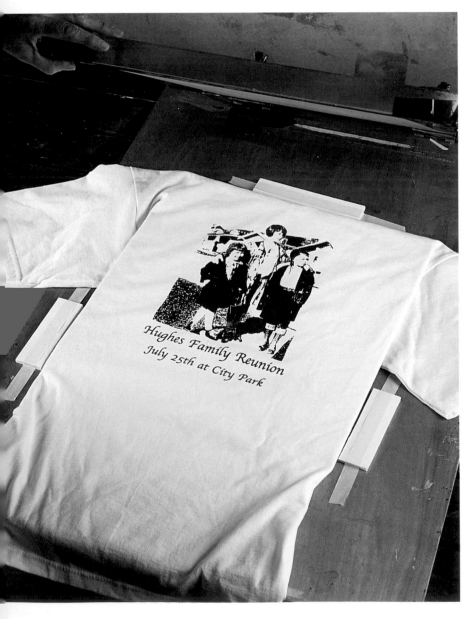

Printing Instructions

1 Use the family photo to make a high-contrast image for the photo-emulsion stencil at your computer or at a copy center. Use the techniques suggested on pages 41 and 42 to create an image you like. Have the finished version printed on one sheet of vellum or two sheets of transparency film. Prepare the photo-emulsion stencil.

2 Attach each T-shirt to a large mat board backing structure, each cut to the same size. Center the area of the T-shirt to be printed on the mat board. Use temporary spray adhesive to hold the shirt in place on the backing structure; if desired, wrap the sleeves around the structure and tape them in place in the back. Use tape to mark the fabric where the edges of the image should go, and also mark with tape the placement of the backing structure on the backboard.

3 After printing the photographic image, add the computer-generated text underneath by creating a second photo-emulsion stencil. Register and print the text on each shirt and allow the shirts to dry on the backing structures.

4 Use an iron to heat set the ink, so the color remains fast during washing.

holiday gift tags

Use an advanced stenciling technique to print these playful
tags for all your holiday packages. The variations provide you
with several alternative methods of creating this project.

Materials and Tools

Screenprinting setup and supplies
White card stock, cut into pieces
Stiff brush
Single-hole punch
Ribbon or brightly colored string

SKILL LEVEL: **Intermediate**
STENCIL TYPE: **Hand stencil**
INK TYPE: **Acrylic paint; 5 colors, including 4 bright colors and black**

Printing Instructions

1 Draw an outline of a light bulb to size on one of the card stock pieces, leaving a working margin around the perimeter of the design. Lay a sheet of transparency film over it, and use the drawing as a guide for cutting a template from the transparency.

2 Position the template over the first card stock piece, spraying temporary adhesive on the back of the template to hold it snugly in place. Apply color to the open area by brushing over the template from the outer edges inward. This will help keep the template from tearing and the paint from bleeding under the edge. Follow this process for each of the card stock pieces. Clean your brush before changing colors.

3 Create another template for the details at the top of the bulb, following the same process as you did in step 1. Use black paint for this layer.

Finishing Instructions

When the paint is dry, cut around the outside of the bulbs and punch a hole in the top for ribbon or brightly colored string.

Variations: There's more than one way to make a gift tag! You can also use your screenprinting skills to make multiples of these tags by using a paper stencil on the screen. First, draw the light bulb and transfer it repeatedly to a paper stencil, creating rows of bulbs on the stencil. Print the first color. Make a stencil for the black details and print on the colored bulbs. Depending on the size of your screen, you could perhaps make a dozen tags at a time.

Also, you can print tags in two colors at once by cutting a stencil with two rows of light bulbs; allow some distance between the rows. Tape the stencil to the screen with the rows heading in the direction you'll pull the squeegee. Print two inks, one on each side of the screen, with the same squeegee. This technique is shown on page 48.

Be sure to use screenprinting inks for the variations.

tree for all seasons pillow

Celebrate the glory of each season with this design that
combines serigraphy and stamping.

Materials and Tools

Screenprinting setup and supplies

Fabric in 2 colors, 1 for the pillow and 1 for the edging

Fabric scissors

Mat board

Pillow form

Rubber cutting block and cutting tool (or purchased stamp)

Brayer

Old manila folder

Iron and ironing board

Sewing machine and thread

SKILL LEVEL: **Intermediate**

STENCIL METHOD: **Photo emulsion (image on frosted polyester film)**

INK TYPE: **Water-based textile ink, 6 colors (brown, light green, dark green, orange, yellow, and red)**

REGISTRATION METHOD: **Masking tape**

Printing Instructions

1 Using the size of the pillow form as your guide, determine the size you'd like the printed area of the pillow to be. On paper, draw a diagram that divides that area into quarters. Determine the dimensions for one of the quarters, adding a 1-inch seam allowance to each of the four sides. Cut eight pieces of fabric to this measurement (four for each side of the pillow), plus a few extras to allow for printing errors.

2 Create a drawing of a bare tree on paper that's the size of the printable area of one of the fabric pieces *excluding* the seam allowance. Using an opaque black marker, transfer the drawing onto a piece of frosted polyester film. Use this imagery to produce a photo-emulsion stencil.

3 Make a backing structure from the mat board for each fabric piece; the backing structure should be exactly the same size as the fabric piece. Affix each piece of fabric to its backing structure with temporary spray adhesive. Register by positioning a backing structure under the polyester film. Use masking tape to mark the registration guides on the backboard. Remove the polyester film and print the trees onto the fabric pieces and let each dry.

4 Cut a small leaf shape from the cutting block. (You can also use a purchased stamp.) Use the brayer to roll out all of the inks except brown on an unfolded manila folder. Use the light green ink and hand stamp the leaves onto the two "spring" fabric squares and the two "summer" fabric squares. Next, add dark green leaves to the two "summer" squares and a few to both of the "fall" squares. Finally, print the orange, yellow, and red leaves on the two "fall" squares. Let the squares dry on their backing structures and heat set the ink with an iron.

Finishing Instructions

1 Sew each set of four squares together to create the front and back panels of the pillow.

2 Again using the pillow form as a guide, determine the width of the edging fabric and cut strips to this size, adding a 1-inch (2.5 cm) seam allowance. With the right sides facing, sew the strips to the two panels to create the front and back of the pillow. Sew the front and back panels together on three sides; in this project, the panels were sewn together with the wrong sides facing and the edges turned under to form a narrow flange. Slip the pillow form inside, and hand sew the final side together. Trim as desired.

family history album

Translate a beloved family photograph into a charming cover for an album full of cherished mementos. This project illustrates the successful layering of color when combining stencil techniques.

Materials and Tools

Screenprinting setup and supplies
Old family photograph
Mat board
Archival paper
Correction fluid or white paint
Bone folder
Gummed linen tape
Ribbon

SKILL LEVEL: **Intermediate**
STENCIL TYPES: **Photo emulsion (image on vellum or double transparency)—brown; indirect (paper)—yellow**
INK TYPE: **Water based; 2 colors (one color must be lighter than the other)**
REGISTRATION METHOD: **Register pins**

Figure 1

Printing Instructions

1 At the computer or copy machine, make a high-contrast image from an old family photograph as shown on the opposite page. Use the techniques suggested on pages 41 and 42 to first copy the photograph, and then enlarge, darken with a marker, or erase with correction fluid until you've created an image you like.

2 At your own printer or a copy center, print the final image on one sheet of vellum or two sheets of transparency film. Print your text to size and use clear tape to collage the image and the text together. Make sure to cut away any vellum or transparency film that may create a layer under the image, because the extra layers of material could distort the image during the exposure process.

3 Cut the mat board pieces to album size. Cut enough for the front and back covers of as many albums as you'll make. Tear the archival paper to the same size and stack it with the front facing up. Punch registration holes in all the sheets and the front covers, centered along the left edge. Pile the back covers face *down* and punch the registration holes at the left, so the holes will match up when the albums are assembled later.

4 Make a paper stencil to print the lighter underlying color (yellow in this project.) Refer to the photo image you've made to determine where you would like an underlying color; this part of the image will serve as a guide for cutting the paper stencil. Since the paper stencil produces a solid area of color that will lie under the more detailed primary image, the shape of the paper cutout can be greatly simplified, as long as it fits within the outer edges of the overlaying image. The paper stencil in this project was cut to the shape of the skirt, as shown in figure 1.

5 Temporarily attach the vellum or double transparency image to one of the album's front covers to serve as a registration guide for the paper stencil print. Position it under the first print you make on the polyester film so the lighter color will appear neatly behind the photographic image, exactly where you want it after both layers of color are printed. Tape the register pins in place on the backboard and remove the film and the guide sheet. Print using the paper stencil. Let the prints from this color run dry.

6 Make the photo-emulsion stencil using the prepared image. Use the darker color to print the front covers and let them dry.

Finishing Instructions

1 With a straightedge as a guide, use the bone folder to crease each sheet about an inch (2.5 cm) from the end with the holes. This will make turning the pages easier. For stability, apply gummed linen tape to the edges of the front covers.

2 Assemble each album by inserting the archival sheets between the front and back covers. Weave ribbon through the registration holes to bind each album together.

Tip: Be sure to use archival materials when you assemble these albums so your family heirlooms are protected. These albums would make a memorable gift for the members of an extended family.

scarf with repeated pattern

Combine a simple pattern with a gossamer fabric to create a luxurious accessory. Two shades of ink add visual interest.

Materials and Tools
Screenprinting setup and supplies
Lightweight fabric
Fabric scissors
Mat board
Iron and ironing board
Needle and thread

SKILL LEVEL: **Intermediate**
STENCIL TYPE: **Photo emulsion**
(image on frosted polyester film)
INK TYPE: **Water-based textile ink;**
2 shades of the same color
REGISTRATION METHOD: **Masking tape**

Printing Instructions

1 Cut the fabric to the desired size. Prepare a loose, repeated design on paper consisting of two rows that span the width of the fabric. Transfer this design to the frosted polyester film using a black marker.

2 Make a photo-emulsion stencil from the image you made in step 1.

3 Prepare two large mat board backing structures that are the width of the fabric and taller than the height of the image. Use temporary spray adhesive to adhere each end of the fabric to a backing structure.

4 Attach the screen to the backboard so you will be able to stretch the excess fabric out to the side along the table. You will print both colors at the same time as described on page 48.

5 Pull the first print on the polyester film to determine registration. Place masking tape strips on the backboard for registration guides and remove the polyester film. Print one end of the scarf and then carefully turn the scarf around so you can print the other end from the same direction. Leave the backing structures in place as the scarf dries.

6 Heat set the textile ink according to the ink manufacturer's instructions.

Finishing Instructions

Finish the scarf by hemming all the raw edges.

Tip: You may find it easier to attach the screen to the backboard in a horizontal orientation, rather than vertical, to create this pattern on the ends of the scarf.

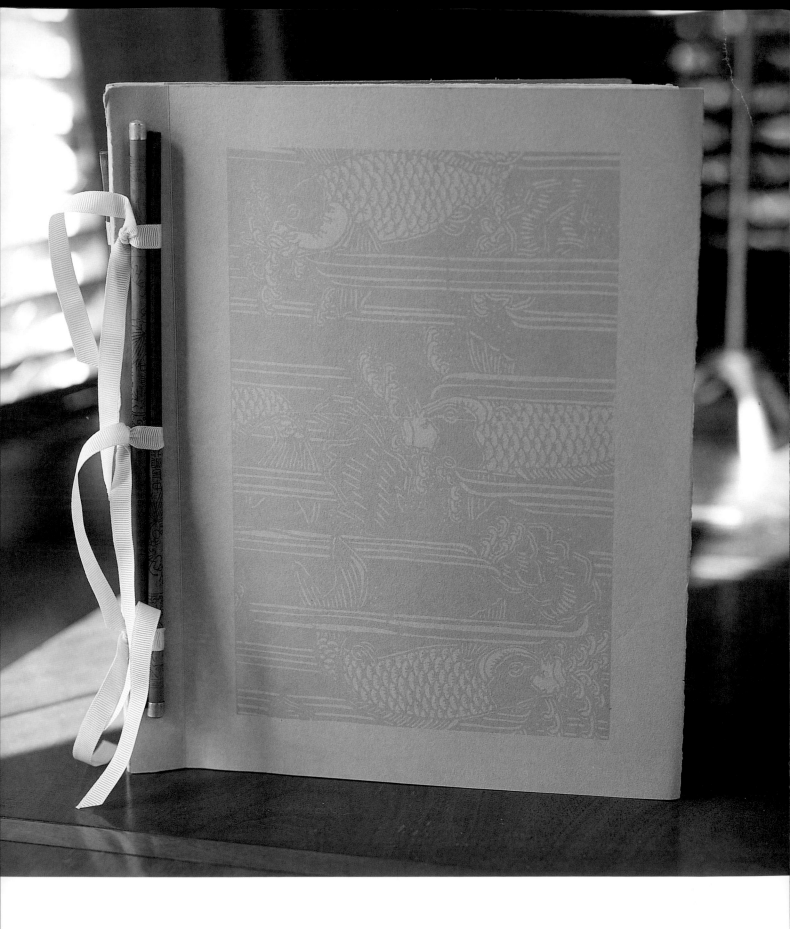

journal with textured pages

Screenprinting can produce delicate imagery, too, as seen in this elegant journal. Use a very transparent ink to create these subtle pages.

Materials and Tools

Screenprinting setup and supplies
6 sheets of archival paper, 22 x 30 inches
 (55 x 76.2 cm), sturdy weight; 5 sheets in
 cream or off-white and 1 sheet in a darker
 color such as tan or gray
Historical image
Gummed linen tape
Bone folder
Ribbon
2 sets of chopsticks

SKILL LEVEL: **Intermediate**
STENCIL TYPE: **Photo emulsion (image on vellum
or double transparency)**
INK TYPE: **Water based; 1 color, very transparent**
REGISTRATION METHOD: **Register pins**

Printing Instructions

1 Tear the paper into pages that are $12\frac{1}{8}$ x 22 inches (30.8 x 55 cm), as shown in figure 1. Then tear them again to the dimensions shown in figure 2. You'll be able to get four pages from each sheet, making 24 pages from the lighter paper and 4 sheets from the darker paper. (The darker sheets will be the covers; two extra sheets are included in case of printing errors.) Follow the tearing procedure in in figures 1 and 2, and you'll end up with the original deckled edges on the outside of each page.

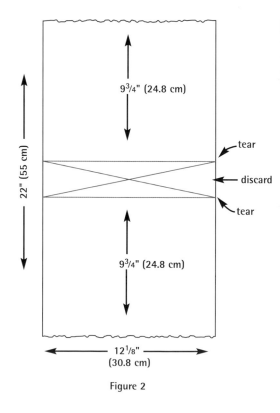

Figure 2

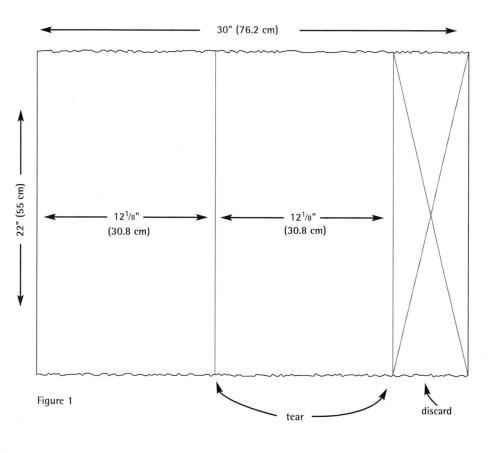

Figure 1

2 Stack the sheets in preparation for hole punching, making sure that all the sheets of the lighter color are face-up, with the deckled side on the right. Arrange two of the darker sheets in a pile as you did the lighter sheets. The other two dark sheets should be facing down with the deckled edges on the right, because they'll be the back cover and need to be in the opposite orientation as the front. (If there are no printing errors, you'll end up with an extra cover...how might you use that in the future?)

3 Punch three registration holes on the left side of all of the sheets, centering the holes. These will serve as the holes through which the book will be bound, so you won't cut off this portion of the sheets after they've been printed.

4 Prepare a high-contrast image and make four transparencies of the image you've developed. (The image used here was from an old book of Japanese stencils.) Make two sets consisting of two transparencies each so you've got two double transparencies. Tape each set together precisely.

5 Prepare one photo-emulsion stencil with the double transparency facing up. For the other stencil, turn the double transparency over with the image facing down so you'll be able to print the design in reverse. If your screen is big enough to accommodate both double transparencies, you'll only have to prepare the one screen, placing both transparencies side by side on it. Leave as much space between them as you can. This will help keep ink from seeping through one while printing the other; when you print, you can use paper to block out the side you aren't printing.

6 Set aside the two darker sheets facing down—they won't be printed at all during the first color run. Print the face-up image on the rest of the sheets, making sure the deckled edge is on the right. You'll notice that the transparent ink looks darker on the darker color of the cover sheet. This is because transparent color is always affected by what's underneath, whether it is printed color or paper color. Let the cover and the sheets dry.

7 Set the two printed cover sheets aside. Turn the remaining sheets over so the deckled edge is on the left and the printed image is facing down. Take the two dark sheets that you set aside in step 6 and add them to this pile, making sure they are facing up with the deckled

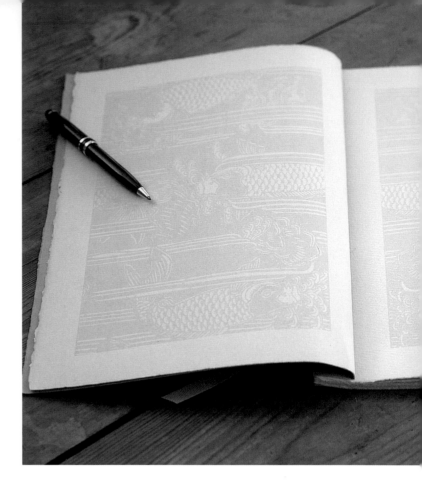

edge on the left as well. Print the reverse stencil on all of these sheets.

Finishing Instructions

1 For strength, apply gummed linen tape to the inside edges of the front and back covers, along the edges where the registration holes are punched. Punch the holes through the linen tape at the appropriate spots, matching the holes already in the sheets. Use a straightedge and the bone folder to crease the covers along the side of the gummed tape.

2 Use the straightedge and the bone folder to crease each sheet along the side with the punched holes. The crease should be made the same distance from the edge as the creases in the cover sheets.

3 Assemble the stack again, adding the front and back cover, and align the holes. With one set of chopsticks underneath and another set on the top, weave a doubled length of ribbon through each of the holes from the front. Loop the ribbon around the two chopsticks underneath and come back up through the same hole. Tie the ribbon around the other set of chopsticks on top and secure with a double knot or bow.

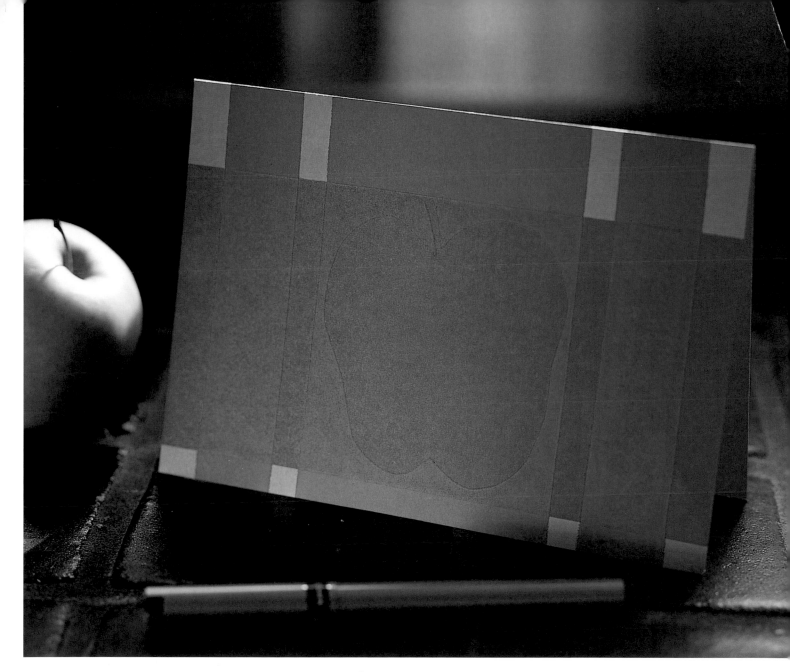

apple-a-day get well cards

Make a supply of these cards to send whenever a friend needs a
cheery greeting. Use two stencils and a combination of opaque and
transparent ink colors to create these bright images.

Materials and Tools

Screenprinting setup and supplies
Colorful card stock
Envelopes, 5¼ x 7¼ (13.2 x 18.4 cm) inches
Bone folder

SKILL LEVEL: **Intermediate**
STENCIL TYPE: **Indirect (2 paper stencils)—red, blue**
INK TYPE: **Water based; 2 colors, 1 of which is transparent**
REGISTRATION METHOD: **Register pins**

Printing Instructions

1 To mark a sheet of the paper with registration guides, draw a dotted line indicating the fold line at 5¼ inches (13.3 cm) and another line at 10¼ inches (26 cm). (After printing, the sides will be trimmed to the edge of the printed image so it will bleed off the edge of the card.) Punch registration holes at the far end of the paper, as shown in figure 1.

2 The first stencil you'll use for this project is a simple rectangle. The color from this stencil (red in this project) shows through the open areas of the second stencil, so the opening in the first stencil needs to be wider than the second stencil. Cut the stencil for the simple rectangle from freezer paper and affix it to the screen. Determine how many sheets of card stock you want to print and punch registration holes in each piece. Print the first color run.

3 The second stencil is a series of rectangles with a floating stencil in the center window. (When creating stencils on freezer paper, remember that the image will print in reverse if you transfer the drawing directly to the paper side of the wrap. To have the image appear exactly as you draw it, reverse the drawing before you transfer it to the paper side of the wrap.) Add the floating stencil with just a touch of glue (photo 1), as described on page 37.

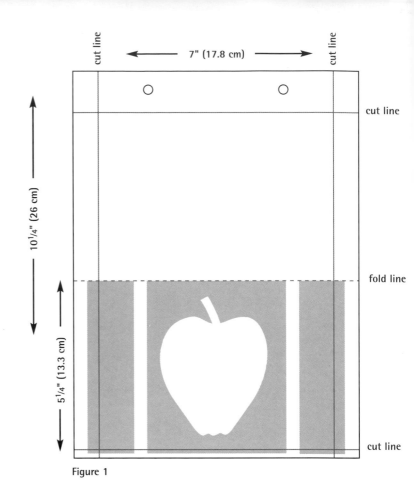

Figure 1

cut line
7" (17.8 cm)
cut line
cut line
10¼" (26 cm)
5¼" (13.3 cm)
fold line
cut line

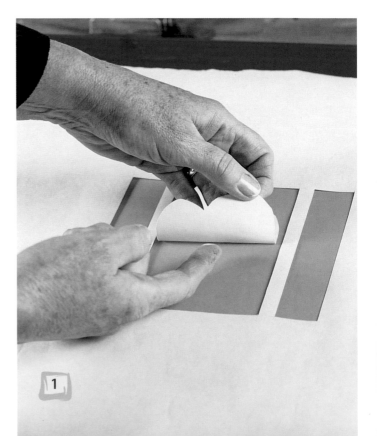

1

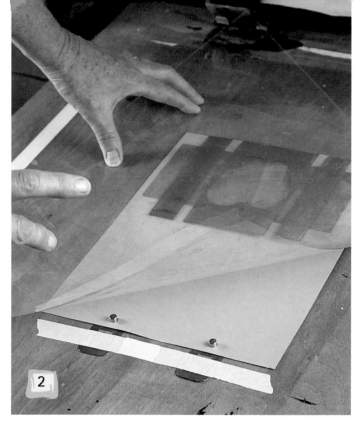

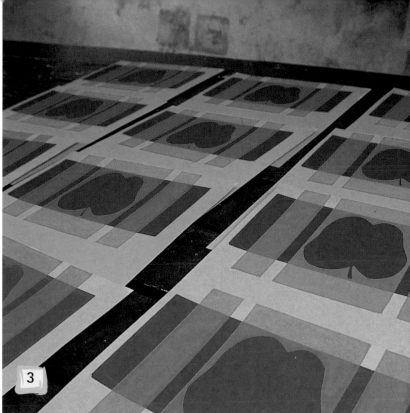

4 As shown in photo 2, register the second color to begin the next color run (transparent blue in this project). Print the second color and let the cards dry (photo 3).

Finishing Instructions

1 After printing, refer to figure 1 and cut the paper down to 5 x 7 inches (12.7 x 17.8 cm) as follows: cut the registration end off at the $10^1/4$-inch (26 cm) line; cut $^1/4$ inch (6 mm) off the opposite end; and cut $^3/4$ inch (1.9 cm) off each side. If the print is off-center, adjust the cut marks accordingly so that the image is centered on the card.

2 Score and fold the cards at the fold line using a bone folder.

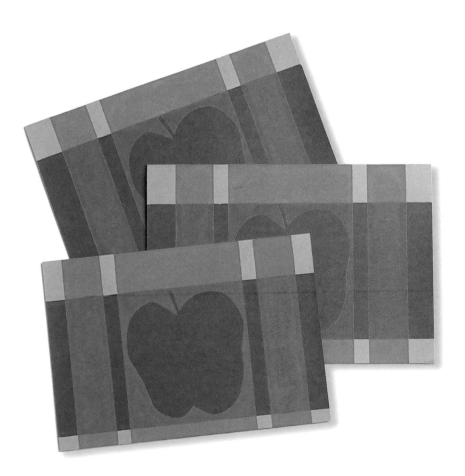

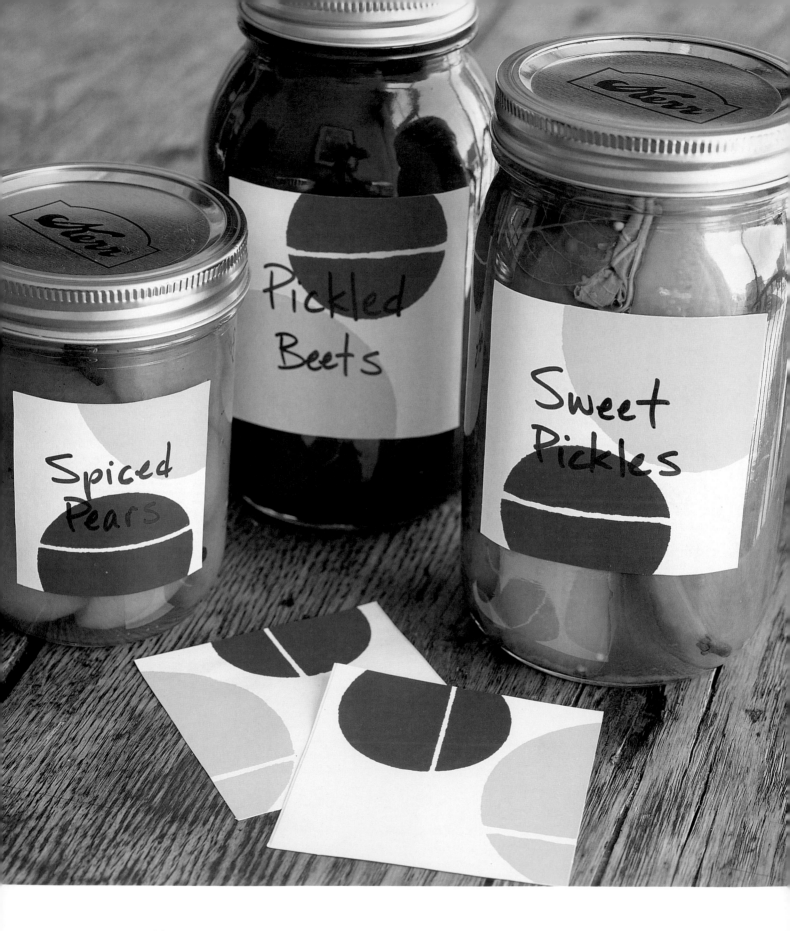

labels for bags, boxes, or bottles

Lend a modern touch with these Pop Art labels. Create one overall pattern and then make the stencils for each color.

Materials and Tools

Screenprinting setup and supplies
Sheet labels with adhesive backing,
 8$^1/_2$ x 11 inches (21.6 x 27.9 cm)
Paper cutter

SKILL LEVEL: **Intermediate**
STENCIL TYPE: **Photo emulsion (image on vellum or double transparency)**
INK TYPE: **Water based; 2 colors**
REGISTRATION METHOD: **Masking tape**

Printing Instructions

1 Create a geometric design to fit within an 8$^1/_2$ x 11-inch (21.6 x 27.9 cm) area. If you are working at the computer, divide the design into two parts by moving to a second page the parts of the design you would like to print in the second color. (In this project, the shapes that are yellow are on one stencil, and the shapes that are maroon are on the second stencil.) Print each page on a sheet of vellum or two sheets of transparency film.

2 If you drew your design by hand and are working at a copy machine, divide the design into two parts by first copying it, using white paper to cover up the shapes that will print in the second color. Then reverse this process and cover the shapes you just copied, making a copy of the shapes that will print in the second color. Get each of the two copies printed on one sheet of vellum or two sheets of transparency film.

3 Use the imagery you created in step 1 or step 2 to produce the two photo-emulsion stencils you need for this project and print.

Finishing Instructions

After printing both colors on the sheets, use a paper cutter or craft knife and straightedge to cut the pages into various sizes for labels.

Variation: Wouldn't this design on colored card stock make fabulous place cards? Choose colors to complement your tableware.

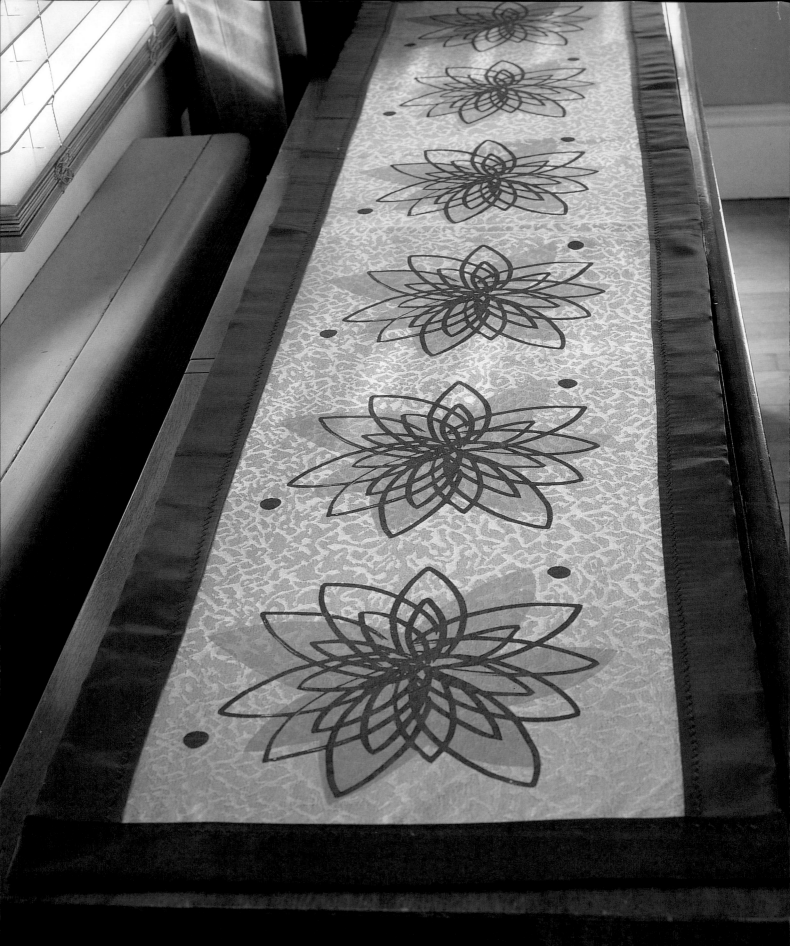

artful table runner

The repeated pattern imparts an air of sophistication to this table runner. Intriguing colors increase the allure.

Materials and Tools

Screenprinting setup and supplies
Fabric
Fabric scissors
Mat board
Iron and ironing board
Blanket edging
Sewing machine and thread

SKILL LEVEL: **Intermediate**
STENCIL TYPE: **Indirect (paper)—orange;
photo-emulsion (image on frosted
polyester film)—maroon**
INK TYPE: **Water-based textile ink, 2 colors**
REGISTRATION TYPE: **Masking tape**

Printing Instructions

1 Cut a long strip of fabric to the size of your choice.

2 Create an image that you'll print in two parts: a background shape in one color and line highlights in another color. A loose image that doesn't require exacting registration is best for this project. Prepare a paper stencil for the background shape; for the second stencil, draw the line highlights on frosted film with an opaque marker.

3 In this project, you will repeat-print the same design at regular intervals along one piece of fabric, as shown on page 49. Attach the paper stencil to the screen. Attach the screen to the backboard so it is easy move the fabric from one side to the other as you print, like an assembly line.

4 Because you'll be printing a repeat pattern on a long strip of fabric, determine the spacing of your pattern before you print. Mark the fabric with masking tape where each image should be printed, placing a piece of tape at the top and bottom of the image, centered above and below it. Mark with a pencil the approximate center on the top piece of tape. You can also place tape along the sides of the area to be printed, if you'd like. Use these markings as a guide for preparing and attaching the mat board backing structures for each image, adhering each backing structure with temporary spray adhesive. Place a second piece of tape above the one at the top of the image and mark its center; you will align this mark with one on the backboard when you print.

5 To prepare for registration, use masking tape to attach the polyester film to the backboard, placing the masking tape along the top edge so there is room for the fabric to lie flat underneath. Print on the film. Position the fabric under the film in the proper place for the first print, smoothing the fabric in each direction. Run masking tape along the top of the backboard above the top of the fabric. Before removing the registration film, mark a line on this tape above the approximate center of the printed image.

6 Print the first color, carefully moving the fabric afterward so you don't smear the wet ink. For the next print, match up the center mark on the top piece of tape on the fabric with the center mark on the line of tape on the backboard. Print and repeat this step as necessary. Let the length of fabric dry before you proceed with the next color run.

7 Prepare the photo-emulsion stencil for the second color, making sure the screen is positioned to allow you to move the fabric in the proper direction as you print. Follow the masking tape guidelines for registration you established in steps 4 and 5. Print the second color run. Leave the backing structures in place as the fabric dries.

8 Heat set the fabric with an iron, following the ink manufacturer's instructions.

Finishing Instructions

Trim the edges and ends with blanket edging as desired.

publicity poster

Incorporate bold design elements to publicize an event in your community. Three different stencil methods are combined to produce this poster.

Materials and Tools

Screenprinting setup and supplies
2 large sheets of tracing paper
Poster board

SKILL LEVEL: **Intermediate**
STENCIL TYPES: **Photo emulsion (image on vellum or double transparency)—black; direct (screen filler)—red; indirect (paper)—green, orange**
INK TYPE: **Water based; 4 colors**
REGISTRATION METHOD: **Register pins**

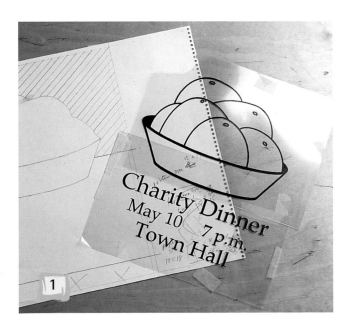

Printing Instructions

1 Cut the poster board to the desired size, adding two inches (5 cm) to accommodate the registration holes. Punch the holes.

2 Create the imagery for the photo-emulsion stencil first because it will be the key image from which you will develop the other stencils, even though you'll be printing the photo-emulsion stencil last in the sequence. The key image is the primary image providing details and definition to your poster, as well as supplying the text. Begin by developing a guide drawing to scale on paper. Determine which elements will be part of the key image. Lay the tracing paper on top of the guide drawing and transfer it to the tracing paper with black markers.

3 Print the text to size and position it on the tracing paper. When you've finished the key image in black on white paper, take it to a copy center to have it transferred to one sheet of vellum or two pieces of transparency film. If the entire image is larger than the copy size available, have it copied in sections and then tape them together with clear tape (photo 1). Cut away as much of the overlap as possible in the image areas if you collage the elements together; this will help keep light refraction to a minimum during the exposure stage. If you have a drawing program on your computer, you could create the entire image and print it on one sheet of vellum or two pieces of transparency film, taping the elements as necessary.

4 Lay a fresh piece of tracing paper over the image on the vellum or double transparency. Draw an outline of the background, or negative, space. Draw the pattern you'll use for the background, and then use the tracing paper as a guide to transfer the image to the screen using a pencil. Use screen filler to block out the screen for the first color (photo 2). After the filler is dry, wash the pencil lines out of the screen with paper towels dampened with mineral spirits so the pencil lines won't print. Clean from both sides, holding the screen under your arm. Register and print the first color, which is red in this project (photo 3).

5 Make a paper stencil for the bowl, tracing it onto a piece of freezer paper from the image you created in step 2. To determine where to print the bowl, tape the key image on one of the poster boards that has already been printed with the first color. Let the image be your guide when you're positioning the poster board under the polyester film to set registration for the green bowl. After you've placed the register pins for this color, remove the guide sheet. Print the bowls and let the posters dry (photo 4). Then repeat these steps to print the oranges (photo 5).

6 Use the image you made in step 3 to prepare the photo-emulsion screen. Register and print the final, darkest color from this screen, black in this project (photo 6).

7 When the prints are dry, use a craft knife and a straightedge to cut off the registration end of the poster board.

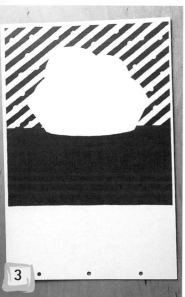

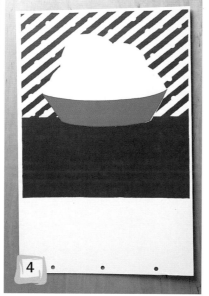

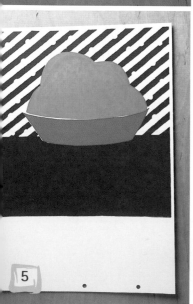

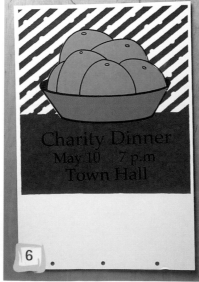

Charity Dinner
May 10 7 p.m
Town Hall

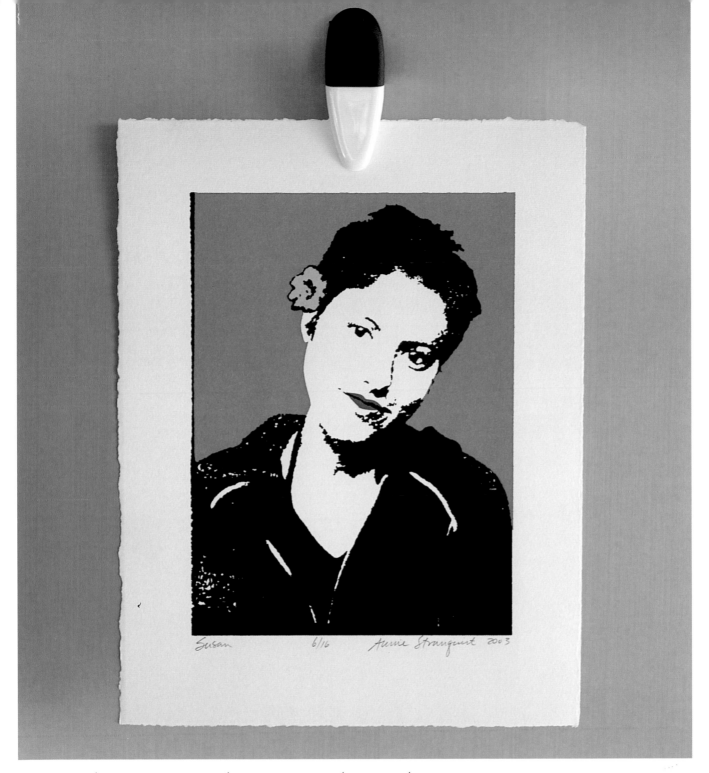

Susan 6/16 Annie Strangquist 2003

photo-booth portrait

Pay homage to Andy Warhol when you create a portrait from a strip of black-and-white snapshots taken at one of the automated photo booths popular at arcades and malls.

Materials and Tools

Screenprinting setup and supplies
Strip of black-and-white photo-booth
 pictures (or any photographic portrait)
Correction fluid or white paint
Archival paper

SKILL LEVEL: **Intermediate**
STENCIL TYPES: **Photo-emulsion (image on
vellum or double transparency)—black;
direct (paper)—blue, yellow, red**
INK TYPE: **Water based; 4 colors**
REGISTRATION METHOD: **Register pins**

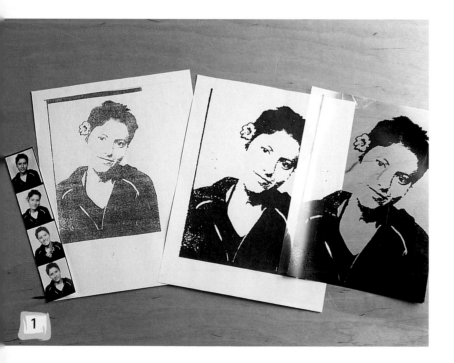

Printing Instructions

1 Select the photo you want to use, but leave the strip intact for future use or enjoyment.

2 At the computer or the copy machine, enlarge the photo to the desired size and create a high-contrast image. If you're working at the copy machine, use a black marker and correction fluid to make alterations and to darken the image where needed. Request one print on vellum or two copies on transparency film from the counter. If you're working at the computer, create the image and print it out on one sheet of vellum or two sheets of transparency film (photo 1).

3 Determine the paper size based on the size of the final image, adding 4 inches (10.2 cm) to each dimension for a 2-inch (5 cm) border, as well as some extra length at one end for registration. Tear the paper to size and punch the registration holes.

4 Use the image on vellum or double transparency as your guide to cut paper stencils for the areas you wish to accent with the underlying colors—lips, eyes, background, etc. Trace the elements you want to highlight onto individual paper stencils and cut them out; in this project, the mouth and flower images were cut on the same stencil, but you can prepare a stencil for each color and print each separately, if you prefer.

5 To determine where to print these colors, prepare a registration guide sheet by indicating with pencil lines the 2-inch (5 cm) border and temporarily taping the prepared image in position (photo 2). Place the guide sheet under the polyester film on which you made the first pull. Set the registration, and then remove the polyester film and the vellum or double transparency attached to the registration guide sheet. Print the first underlying color on the guide sheet. Here, the blue background was added first. Print the first color on all the pieces of paper and let them dry.

6 Attach the vellum or double transparency to the guide sheet prior to registering the next color (or colors); after you've set the registration, remove the polyester film and the prepared image and again print on the guide sheet; here, the yellow and red were printed at the same time from the paper stencil cut in step 4, using a different squeegee for each color as shown on page 48 (photo 3).

7 After all of the underlying colors have been printed, prepare the photo-emulsion stencil using the image you made in step 2. Register and print this stencil using the darkest color (black in this project, as in photo 4).

8 Sign, number, and date your serigraphs in pencil along the bottom as suggested on page 30.

Tip: This project illustrates the importance of using a registration guide sheet throughout the printing process. Sometimes it is easy enough to register without printing on the guide sheet itself when you register the subsequent colors in your project; you can instead use one of the prints from the previous color run. But in this project, when you have elements that require exacting registration, it is helpful to continue to print on the guide sheet itself so you can be certain the subsequent colors (the yellow and red) are printing in the proper position. Then, it's just as easy to use a print to register the final color, because the most exacting elements have already been placed. Assess each project individually to determine when to print on the guide sheet throughout the stages of a project.

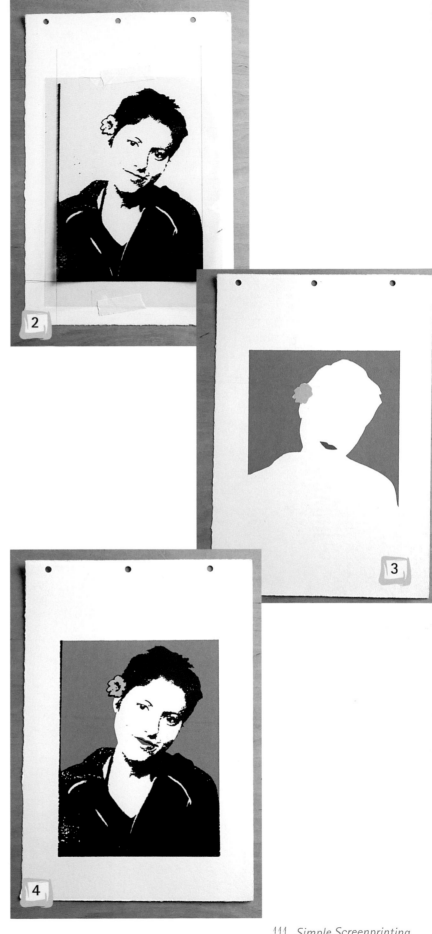

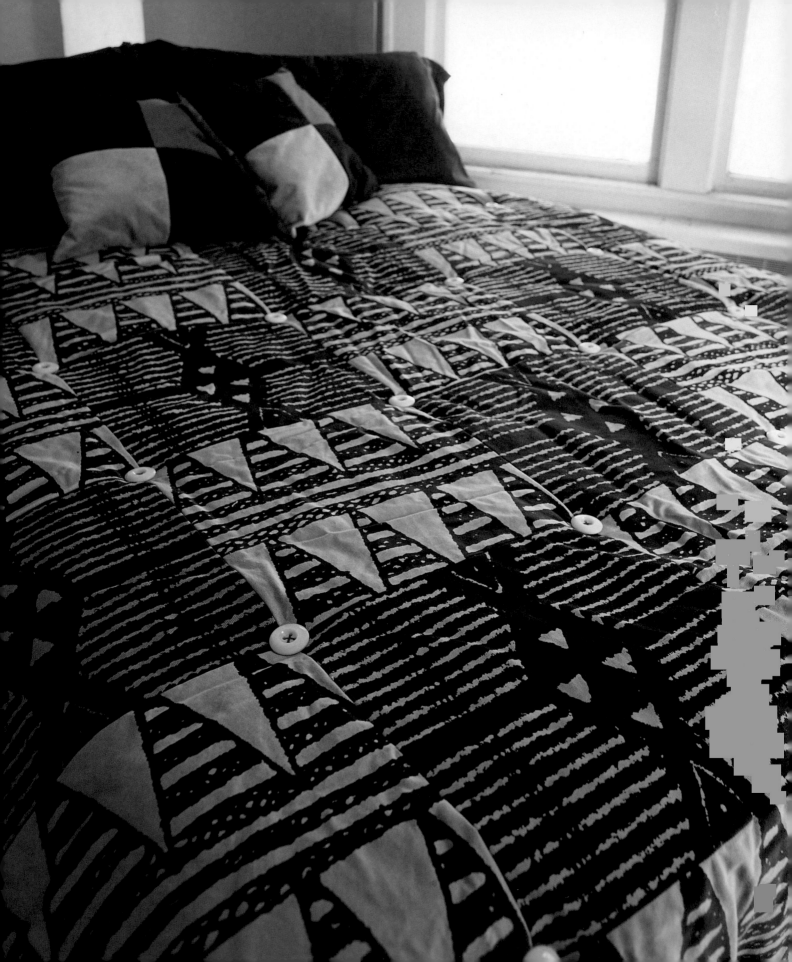

patchwork quilt

This unique quilt is constructed of squares printed with ethnic imagery. Choose bright fabric colors to complement the designs you print.

Materials and Tools

Screenprinting setup and supplies
Fabric in 4 colors, 3 for the front squares and 1 for the backing (at least 5 yards of 45-inch [114.cm] fabric for the top, with a similar amount for the backing)
Fabric scissors
Poster board
2 found images (the ones used in this project are African designs)
Iron and ironing board
Sheet batting
Large, heavy-duty upholstery or safety pins
Wide ribbon, at least 20 yards
Large decorative buttons
Embroidery floss and needle
Sewing machine and thread

SKILL LEVEL: **Intermediate**
STENCIL TYPE: **Photo-emulsion (image on vellum or double-transparency)**
INK TYPE: **Water-based textile ink; 1 color**
REGISTRATION METHOD: **Masking tape**

Printing Instructions

1 Cut at least 30 squares of fabric, each 15 x 15 inches (38.1 x 38.1 cm). Determine a pleasing color arrangement for the patchwork and from that design, you can determine how many squares you'll need of each color in your quilt. Be sure to cut a few extra squares to allow for mistakes in printing.

2 Divide the total number of squares into two equal groups. You'll use one design for one group of squares and the other design for the other group of squares.

3 To make backing structures, cut identical poster board squares that are 15 x 15 inches (38.1 x 38.1 cm), one for each fabric square. Use temporary spray adhesive to attach a fabric square to a poster board square, making sure that all the fabric squares are attached to their respective poster board squares in the same place. Now the fabric squares are ready for printing and can be handled as easily as if they were paper.

4 At a copy center, have each of the found images enlarged and printed on one sheet of vellum or two sheets of transparency film so they are slightly smaller than 15 x 15 inches

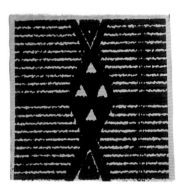

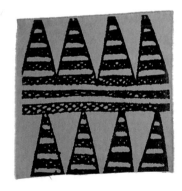

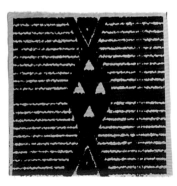

(38.1 x 38.1 cm). Because this is larger than the standard paper size that's available in most copy centers, you can enlarge the images in sections and tape them together to reach the proper size. If there is any overlap in the image areas when you tape the pieces together, trim away as much of it as possible. This will keep light refraction to a minimum during the exposure stage.

5 Use one of the sheets you made in step 4 to prepare a photo-emulsion stencil on the screen.

6 Register with masking tape and print the first set of fabric squares, using temporary spray adhesive to hold each backing structure in place on the backboard as you print.

7 Prepare the second photo-emulsion stencil. Register and print the second set of fabric squares.

8 Heat set the fabric pieces at the ironing board, following the ink manufacturer's instructions.

Finishing Instructions

1 Lay the squares out in the pattern you've chosen, alternating the two printed patterns throughout, or use the design in figure 1. Sew the squares together, a row at a time, using 1-inch (2.5 cm) seams. Stitch the rows together to complete the top of the quilt. Press the seams.

2 To make the backing of the quilt, measure the front of the quilt. You will cut pieces of the backing fabric to this measurement plus several additional inches (5 cm) all around to allow for sandwiching the two sides together around the batting. Include a little extra for seam allowances, too. Stitch the backing pieces together, right sides facing. You might need the extra fabric allowance in case the pieces don't line up perfectly at a later stage.

3 Place the backing on a bed or the floor, right side down. Add a layer of batting on top. Place the screenprinted top right side up on top of the batting. Use the upholstery or safety pins to pin all the pieces together, starting in the center and working your way out, smoothing out wrinkles and folds as you go.

4 Use embroidery floss to sew the buttons at the corners of the squares, starting from the center. You can remove the pins from the center of the quilt after the buttons are in place. Use the pins to secure the edges of the quilt in place for the next step.

5 If necessary, trim the back piece to size.

6 Bind the edges as desired. In this project, wide ribbon was used to encase the raw edges.

Tip: This quilt fits either a full- or queen-size bed, with a little overhang. Adjust the size of your squares accordingly if you make a quilt for a different size mattress, or if you'd prefer a little longer overhang.

B	**A**	**B**	**A**	**B**
A	**B**	**A**	**B**	**A**
B	**A**	**B**	**A**	**B**
A	**B**	**A**	**B**	**A**
B	**A**	**B**	**A**	**B**
A	**B**	**A**	**B**	**A**

Figure 1

A- Design 1

B- Design 2

Dark Gray- Color 1

Light Gray- Color 2

White- Color 3

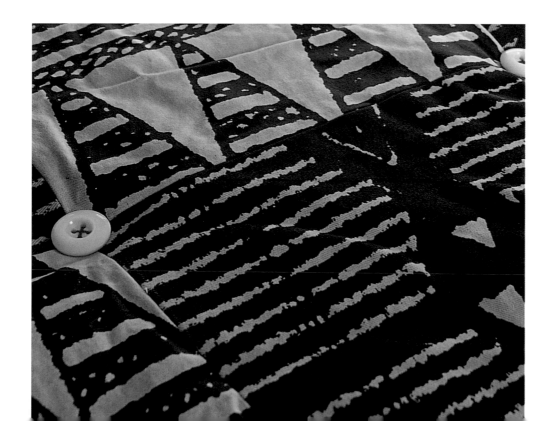

gallery

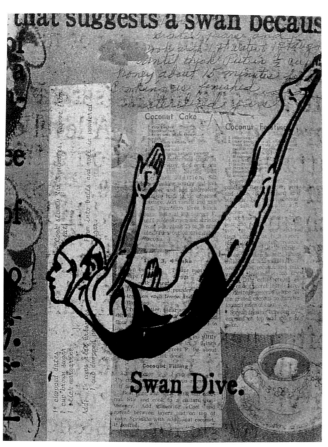

Melissa Harshman, *Swan Dive*, 2001. Four-color separation image with emulsion stencil. 14 x 11 in. (35.6 x 27.9 cm). Photo by artist.

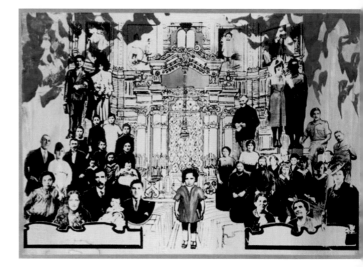

Mandy Wolpert, *Family Reunion*, 2002. Photographic-emulsion stencil, paint. 11^1/5 x 16^1/2 in. (29.2 x 42 cm). Photo by Greg Piper.

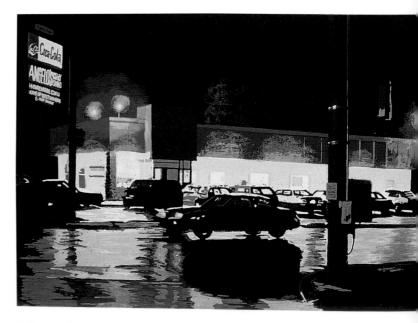

William R. Stolpin, *Angelo's*, 1993. Hand-painted glue, tusche stencils. 12^3/4 x 17^1/2 in. (32.4 x 44.5 cm). Photo by artist.

Edwin Martin, *Bayou Teche*, 1996. Emulsion stencils, acrylic ink. 19 1/2 x 17 in. (49.5 x 43.2 cm). Photo by George Chambers.

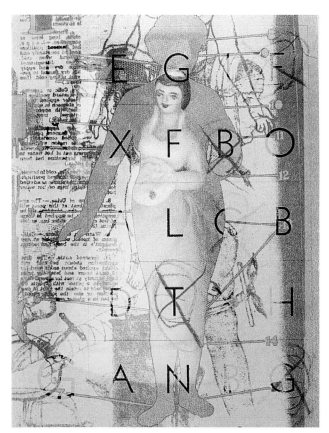

Melissa Harshman, *Wedding Rites #1*, 1998. Four-color separation image with emulsion stencil. 30 x 22 in. (76.2 x 55.8 cm). Photo by artist.

Edwin Martin, *Lake Martin*, 1999. Emulsion stencils, acrylic ink. 18 x 23 in. (45.7 x 58.4 cm). Photo by George Chambers.

Lynwood Kreneck, *Winter Comes to Cardboard Kitchen*, 1992. Water-based ink, photo-emulsion stencils, hand-cut film. 13^1/$_2$ x 16 in. (34.3 x 40.6 cm). Photo by Eleanor Kreneck.

Lynwood Kreneck, *Little Clown Dog/The Music Lesson*, 1993. Monoprint with drawing and sewing. 37^1/$_2$ x 25^1/$_2$ in. (95.3 x 64.8 cm). Photo by Eleanor Kreneck. Collection of Texas Tech University.

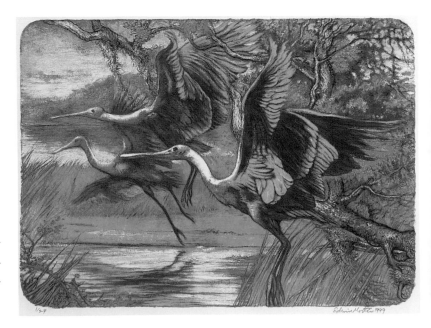

Edwin Martin, *Spoonbills*, 1999. Emulsion stencils, acrylic ink. 17 x 23^1/$_2$ in. (43.2 x 59.7 cm). Photo by George Chambers.

Lynwood Kreneck, *Wedding Feast/Wooden Bride*, 2002. Water-based ink, photo-emulsion stencils, hand-cut film. 9 x 12 in. (22.9 x 30.5 cm). Photo by Eleanor Kreneck. Created and printed at Flying Horse Editions, Orlando, Florida.

Laura Ruby, *The Secret of Red Gate Farm*, 1998. Photo-emulsion stencil. 16 x 18 in. (40.6 x 45.7 cm).

Laura Ruby, *The Secret of Red Gate Farm* (detail)

Annie Stromquist, *Acrobats 1*, 2003. Collaged elements including screenprinted stripes on paper, button, paper stencils. 5 x 11 in. (12.7 x 27.9 cm). Photo by Bill Livingston.

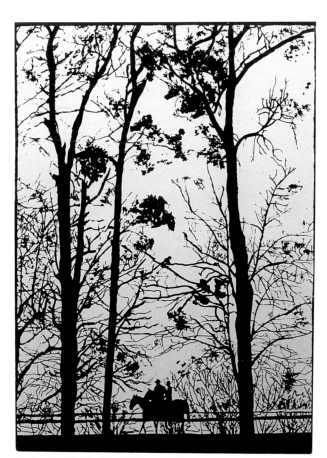

Marian Shuff, *The Good Life*, 1992. Photo stencil, blended color. 12 x 8¹/₄ in. (30.5 x 21 cm).

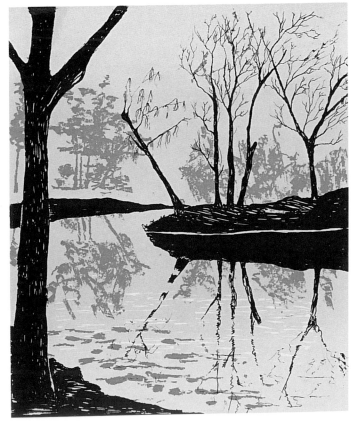

Marian Shuff, Untitled, 1990. Emulsion stencil, two-color blends. 101/4 x 81/2 in. (26 x 21.6 cm). Photo by Bill Livingston.

Judy Chan, *The Question is Where*,
2002. Photo monoprint, film sten-
cil, hand colored. 12¹/₂ x 16¹/₂ in.
(31.8 x 41.9 cm). Photo by artist.

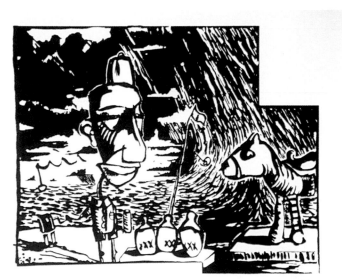

Ian F. Thomas, *Moonshine Pony Ride*,
2003. Painted drawing fluid, screen filler
stencil. 9¹/₄ x 11 in. (23.5 x 27.9 cm).
Photo by artist.

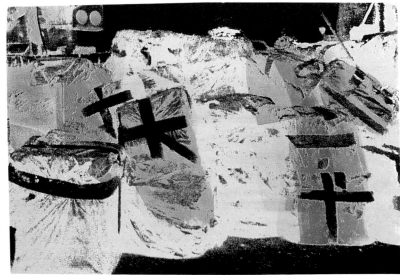

Judy Chan, *Bundle 2*, 1985. Photographic
image with emulsion stencil, collaged.
19¹/₄ x 15¹/₄ in. (48.9 x 38.7 cm).

Louise O'Boyle, *Two Sides*, 1996. Paper stencil, photographic images, open screen color, machine-embroidered plastic sheet. 31^1/$_2$ x 23 1/$_2$ in. (80 x 60 cm). Photo by Connor Tilson.

Louise O'Boyle, *By the Sea,* 1996. Paper stencil, open screen color, machine-embroidered plastic layered in sections. 31^1/$_2$ x 23^1/$_2$ in. (80 x 60 cm). Photo by Connor Tilson.

Judy Chan, *The Question is Why,* 2002. Photo monoprint, film stencil, hand colored. 7^7/$_8$ x 8^1/$_8$ in. (20 x 20.4 cm). Photo by artist.

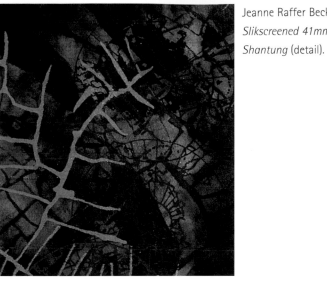

Jeanne Raffer Beck, *Silkscreened 14mm Shantung*,
2003. Thermal stencil, wax stencil with dyes and tex-
tile paints, art fabric. 43 x 62 in. (109.2 x 157.5 cm).
Photo by Richard Margolis.

Anne Silber, *Late October*, 2000.
Hand-cut lacquer film stencils with
transparent-based inks. 17 x 24 in.
(43.2 x 61 cm). Photo by artist.

Claire Rau, *Selections from Cesare Ripa's* Iconologica, 2003. Photographic image with emulsion stencil. 7 x 51/2 x1/2 in. (17.8 x 14 x 1.3 cm). Photo by artist.

Tim Murray, *Untitled Page*, 2003. Dry media photosilkscreen on torn book page, printed through fine mesh with cotton. 6 x 9 in. (15.2 x 22.9 cm). Photo by artist.

Beth Grabowski, *Fibodotcci (Skip)*, 2000. Photo-emulsion stencils and collagraph. 47 x 29 in. (119.4 x 73.7 cm). Photo by artist.

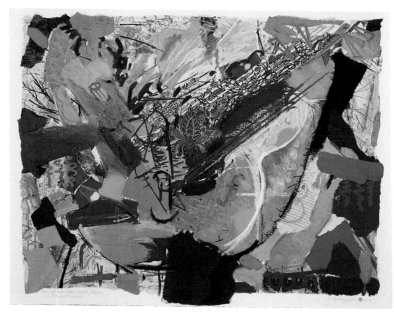

J. C. Heywood, *Study in Surfaces*, 1999. Ultraviolet screenprint. 30 x 41 in. (75 x 105 cm). Photo by artist.

Annie Stromquist, *Crossroad 4*, 2004. Enlarged hand-drawn image, emulsion stencil, one paper stencil. 12 x 22 in. (30.5 x 56 cm). Photo by Bill Livingston.

Annie Stromquist, *Crossroad 1*, 2003. Enlarged hand-drawn image, emulsion stencil. 22 x 32 in. (56 x 81.3 cm). Photo by Bill Livingston.

glossary

Acid-free. Materials and papers without acidity. Also called "pH neutral."

Archival. Long-term stability and resistance of a material to aging; it generally refers to an acid-free material.

Archival paper. Paper that resists brown spots and yellowing.

Bleed edge. A printed image that comes to the edge of the paper, having no border.

Block out. A masking material used to cover areas of the screen that are not to be printed.

Color separation. The process of creating a stencil for each color of an image.

Continuous tone. Gradual change from one color to another, or the range of grays between black and white.

Deckle. The ragged edge on handmade paper.

Degrease. The process of removing oil from screen mesh; new screens require degreasing before use, although degreasing may occasionally be needed throughout a screen's life.

Direct stencil. A stencil created by applying a block-out medium directly to the screen.

Durometer. The term describing the level of hardness of a squeegee blade.

Edition. The total number of identical, original prints made of one image, numbered sequentially and signed by the artist.

High contrast. An image or stencil made with black ink on white paper or film, having no shading or gray tones.

Indirect stencil. A stencil created away from the screen and then attached prior to printing.

Masking film. Transparent film in various colors with a plastic backing used to cut stencils for the photo-emulsion process.

Mesh. The woven polyester fabric of a screen.

Monofilament. Fabric woven from single threads; used in making screen mesh.

Monoprint. The result obtained from printmaking methods that yield only one unique print.

Multifilament. Fabric woven from strands made up of multiple threads; used in making screen mesh.

Negative. The reverse of an image, where the areas normally shown as dark appear light. In screenprinting, printing the negative space means printing the background rather than the image itself.

Opaque color. Color through which light cannot be seen.

Overlaying color. The color printed on top of part or all of another color; an overlaying color might also be printed to correct a poorly printed or unsatisfying underlying color. See **underlying color.**

Photo emulsion. Light-sensitive solution used in stencil making.

Photo-emulsion stencil. A stencil created by exposing a screen coated with light-sensitive emulsion.

Pochoir. The method of making an individual print by brushing through a stencil.

Positive. Refers to the primary objects or shapes in a composition, excluding the background.

Reduction printing. A method of printing using only one screen for every color in the image. Each color is printed after applying a block-out medium to the screen, with no block-out being removed. The open or unprinted areas of the screen become increasingly smaller during the process.

Registration. A method used to insure that colors line up correctly and are printed in the right place on each piece of paper or fabric in the edition.

Repeat-printing. Printing an image more than once on the same piece of fabric or paper. Often refers to printing in measured increments along a length of fabric, assembly-line style.

Retarder. An ingredient added to ink to slow the drying process and prevent the ink from clogging the screen while printing.

Screen. A wooden or aluminum frame with polyester mesh stretched over it; stencils are attached to the screen or created directly on it.

Screen filler. A medium used to block out areas of the screen that are not to be printed.

Screenprinting. A printing method that produces prints by using a squeegee to push ink through a screen.

Scoop coater. A tool used to apply photo emulsion to a screen.

Serigraphy. The term used for fine art screenprinting.

Solvent. A toxic chemical used to clean oily block-out materials from a screen.

Squeegee. A long polyurethane blade attached to a wooden handle used for screenprinting; this tool pushes the ink through the screen.

Stencil. A blocking material with a series of open areas through which ink can pass to produce an image underneath. See **direct stencil, indirect stencil,** and **photo-emulsion stencil.**

Tooth. Refers to the relative roughness of a material's surface.

Transparent color. Color through which light or another color can be seen.

Trapping. The method of printing underlying image areas slightly larger so the overlaying color will overlap and cover the edge of the underlying color, making registration a little easier.

Underlying color. A color printed first that becomes partially or totally hidden by a subsequent layer of color. See **overlaying color.**

Well. The interior portion of the screen where the ink is applied.

bibliography

Adam, Robert and Carol Robertson. *Screenprinting: The Complete Water-Based System*. London: Thames & Hudson, 2003.

Ayres, Julia. *Printmaking Techniques: Collagraph, Engraving, Etching, Linocut, Lithography, Screen Printing, Woodcut*. New York: Watson-Guptill Publications, 1993.

Dunnewold, Jane. *Complex Cloth: A Comprehensive Guide to Surface Design*. Woodinville, Washington: Martingale & Company, 1996.

Faine, Brad. *The Complete Guide to Screen Printing*. Cincinnati, Ohio: North Light Books, 1993.

Henning, Roni. *Screenprinting: Water-Based Techniques*. New York: Watson-Guptill Publications, 1994.

Laury, Jean Ray. *Imagery on Fabric: A Complete Surface Design Handbook*. 2nd ed. Lafayette, California: C&T Publishing, Inc., 1997.

Martin, Judy. *The Encyclopedia of Printmaking Techniques: A Comprehensive Visual Guide to Traditional and Contemporary Techniques*. New York: Sterling Publishing Co., Inc., 2002.

Ross, John, Clare Romano, and Tim Ross. *The Complete Printmaker: Techniques, Traditions, Innovations*. Rev. ed. New York: The Free Press, 1990.

Saff, Donald and Deli Sacilotto. *Printmaking: History and Process*. New York: Holt, Rinehard and Winston, Inc., 1978.

Thompson, Jason. *Making Journals by Hand: 20 Creative Projects for Keeping Your Thoughts*. Gloucester, Massachusetts: Rockport Publishers, Inc., 2000.

Whale, George and Naren Barfield. *Digital Printmaking*. New York: Watson-Guptill Publications, 2003.

acknowledgments

I would like to thank my editor, Valerie Shrader, for her wisdom and expert guidance at every turn. She is exceptional and I have learned so much from her. I knew when I met him that Tom Metcalf would do wonders in designing this book, and I thank him for his many creative strengths and enthusiasm for this project. I thank Keith Wright for his beautiful photography and visual know-how. I thank Rebecca Guthrie for her dual role as research assistant and detective extraordinaire. I have felt honored to work with Lark to make this book.

I am appreciative to the Beverly G. Alpay Memorial Fund for awarding me a grant during the creation of this book.

I am grateful to my family and friends, near and far, for wisdom and support during this project and beyond.

Annie Stromquist, *Hall of Mirrors*, 2004. Collaged mixed media elements including screenprinted paper, paper stencils. 10 1/2 x 9 in. (26.7 x 22.9 cm). Photo by Bill Livingston.

index

a note about suppliers

Usually, the supplies you need for making the projects in Lark books can be found at your local craft supply store, discount mart, home improvement center, or retail shop relevant to the topic of the book. Occasionally, however, you may need to buy materials or tools from specialty suppliers. In order to provide you with the most up-to-date information, we have created a list of suppliers on our website, which we update on a regular basis. Visit us at www.larkbooks.com, click on "Craft Supply Sources," and then click on the relevant topic. You will find numerous companies listed with their web address and/or mailing address and phone number.